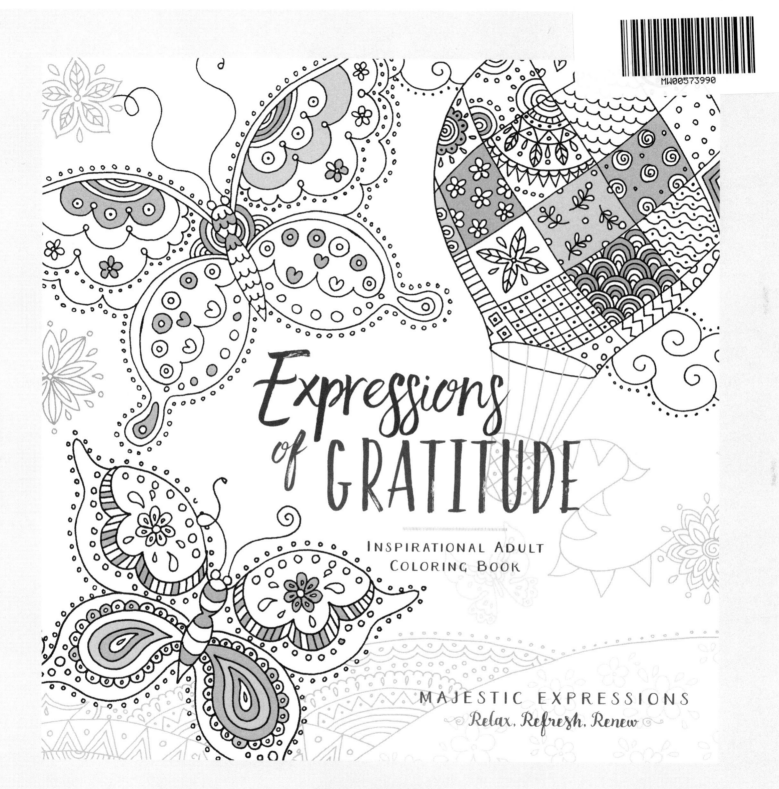

Expressions of GRATITUDE

INSPIRATIONAL ADULT COLORING BOOK

MAJESTIC EXPRESSIONS
Relax, Refresh, Renew

BroadStreet
PUBLISHING

MW00573990

BroadStreet Publishing Group LLC
Racine, Wisconsin, USA
Broadstreetpublishing.com

MAJESTIC EXPRESSIONS
Expressions of GRATITUDE
© 2016 by BroadStreet Publishing

ISBN 978-1-4245-5257-3

Cover design by Chris Garborg | garborgdesign.com.
Compiled and edited by Michelle Winger.

Printed in the United States of America.

16 17 18 19 20 21 22 7 6 5 4 3 2 1

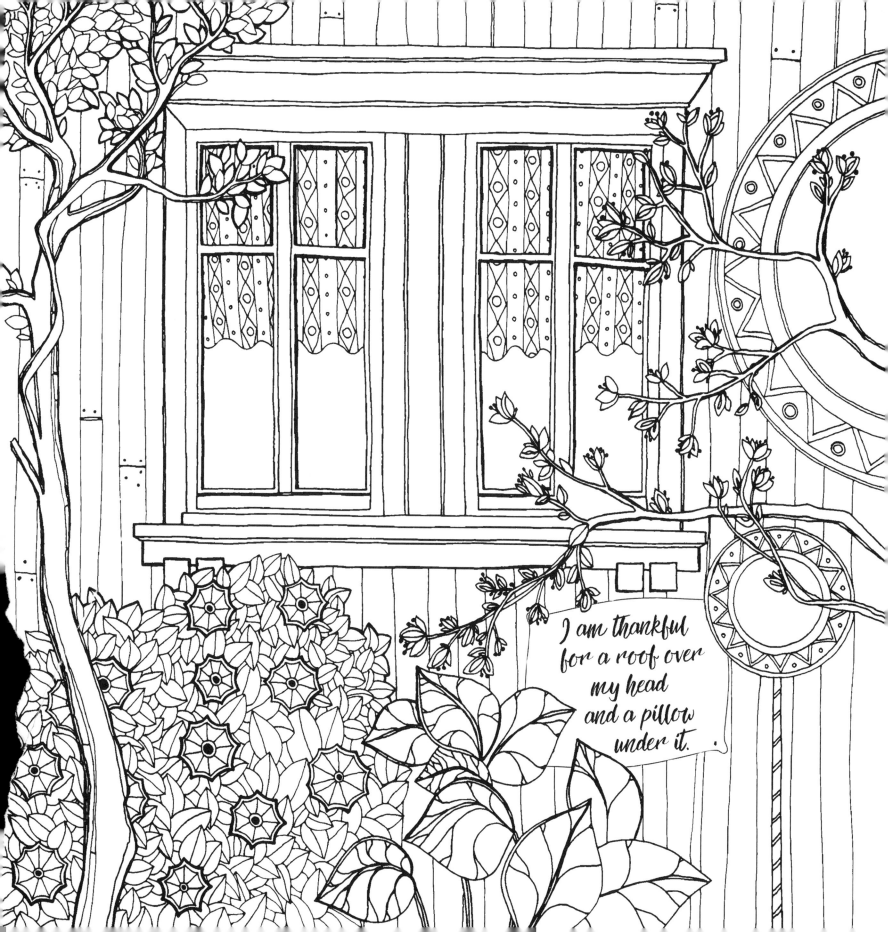

I am thankful
for a roof over
my head
and a pillow
under it.

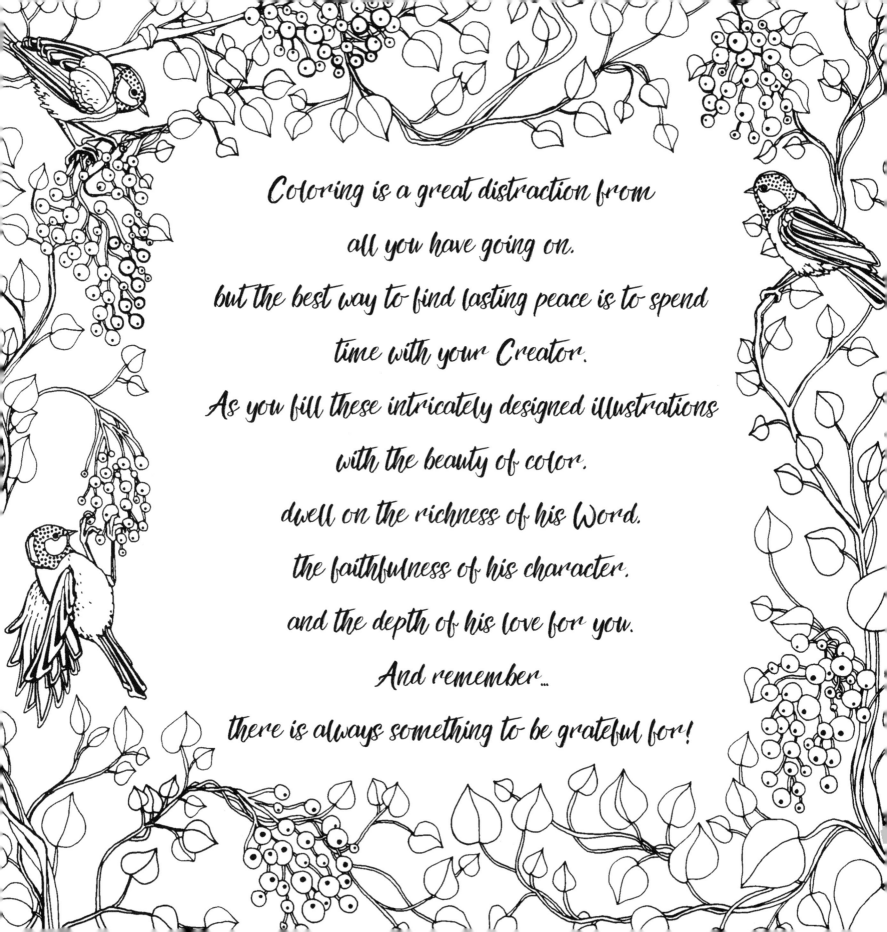

Coloring is a great distraction from
all you have going on.
but the best way to find lasting peace is to spend
time with your Creator.
As you fill these intricately designed illustrations
with the beauty of color.
dwell on the richness of his Word.
the faithfulness of his character.
and the depth of his love for you.
And remember...
there is always something to be grateful for!

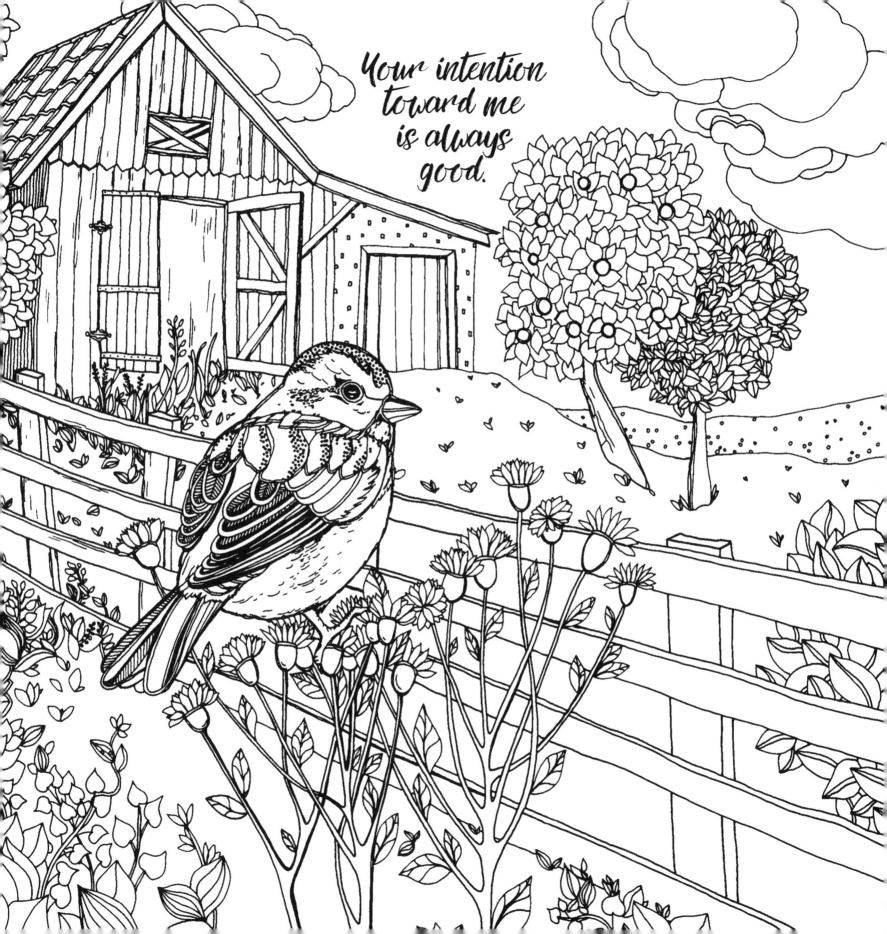

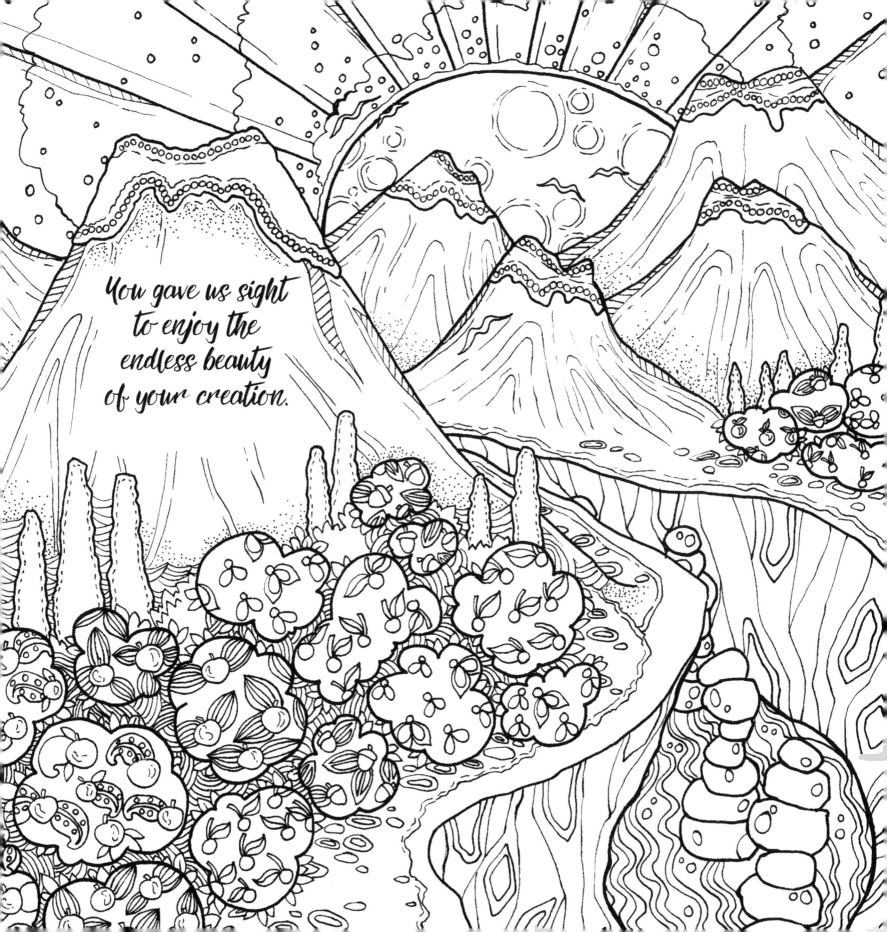

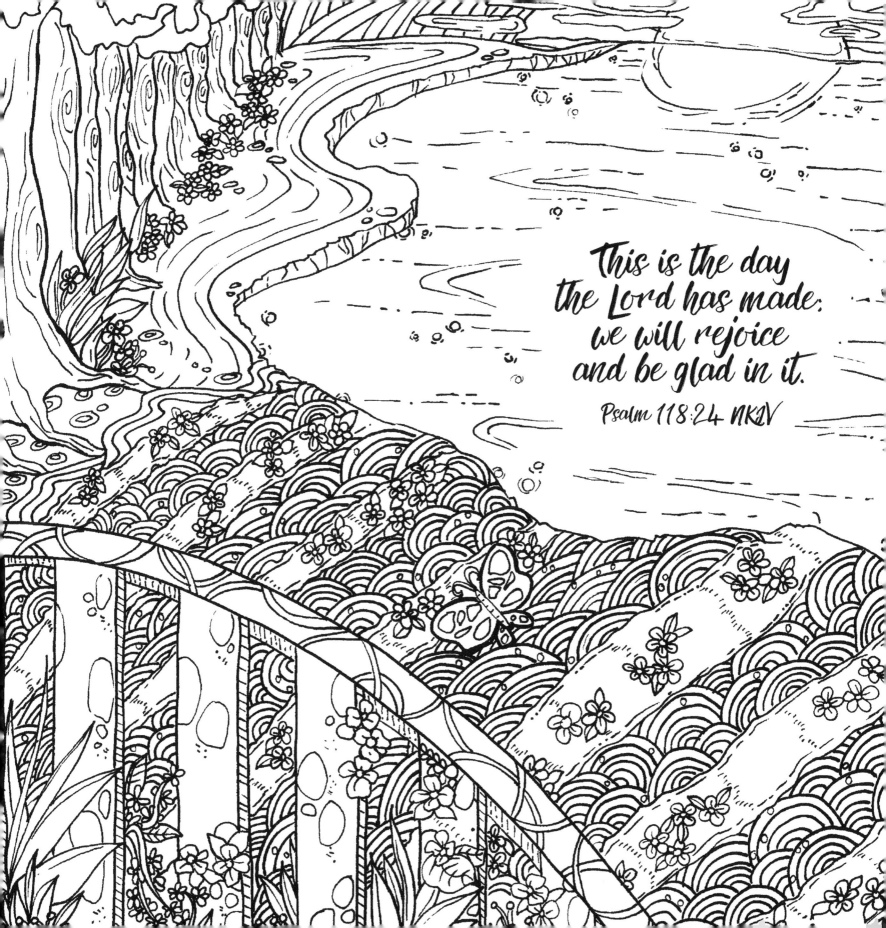

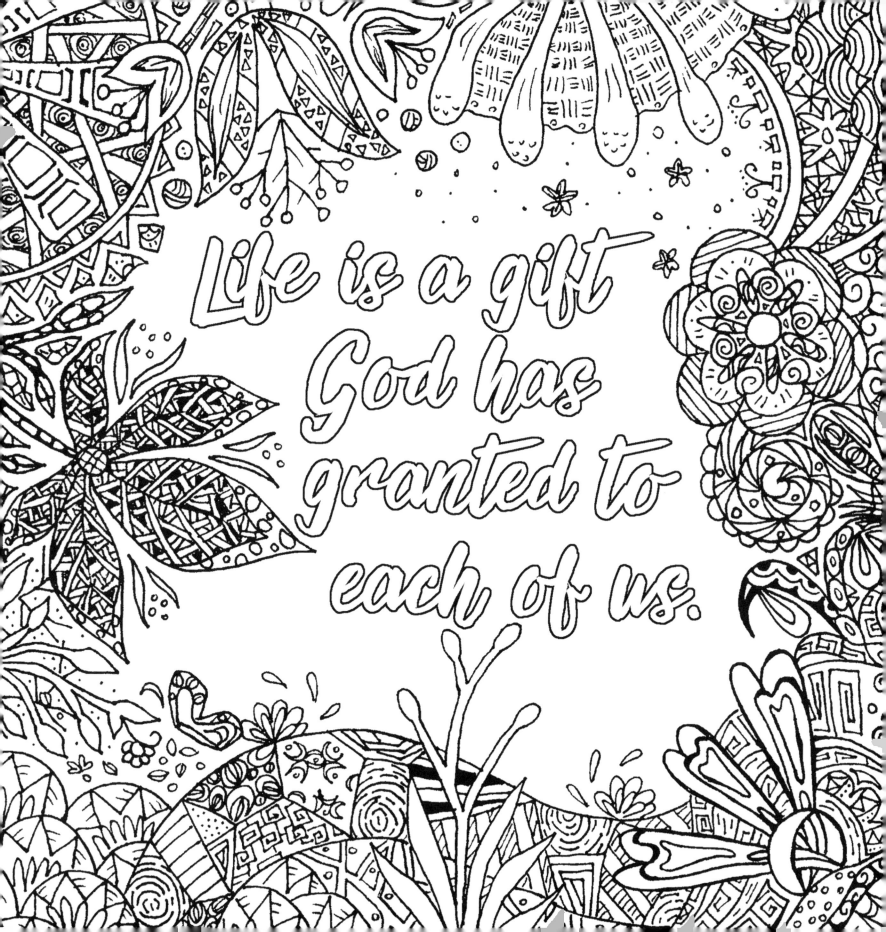

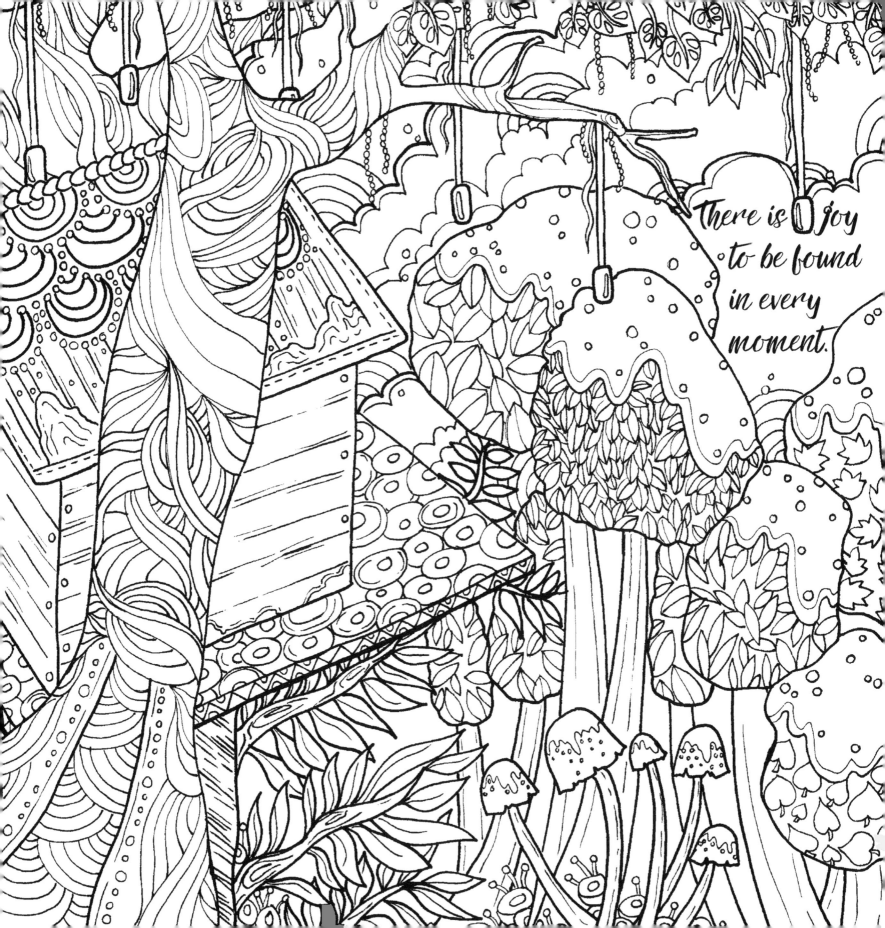

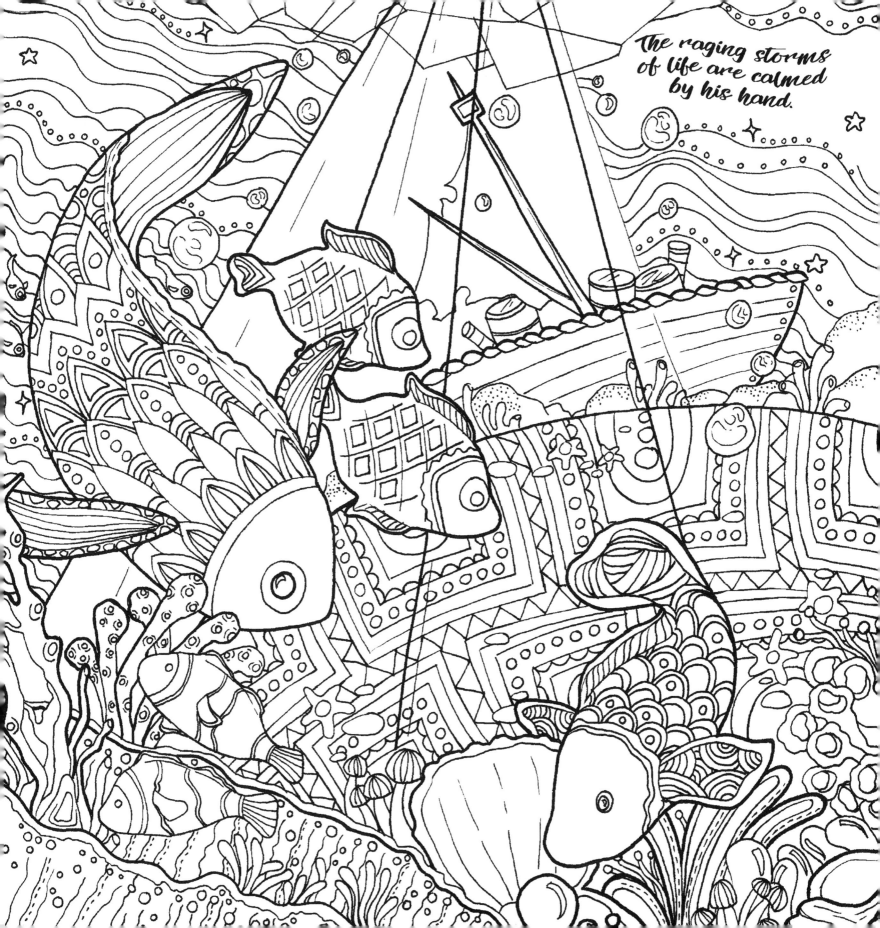

The raging storms
of life are calmed
by his hand.

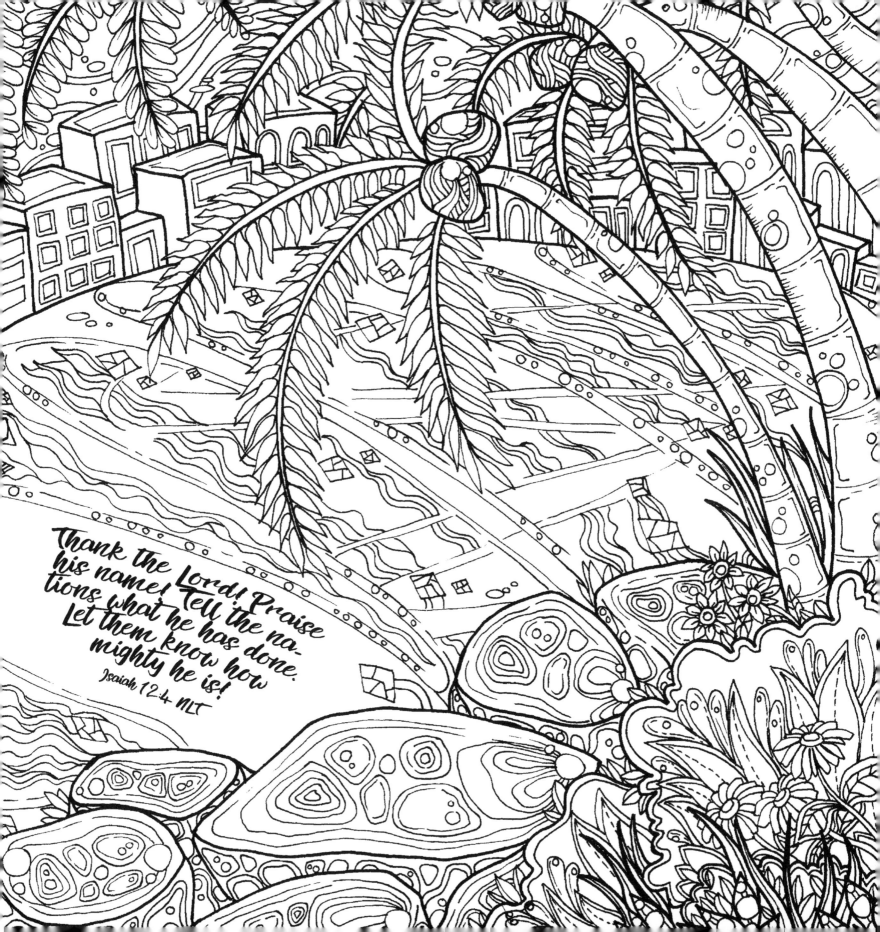

Thank the Lord! Praise his name! Tell the nations what he has done. Let them know how mighty he is!

Isaiah 12:4 NLT

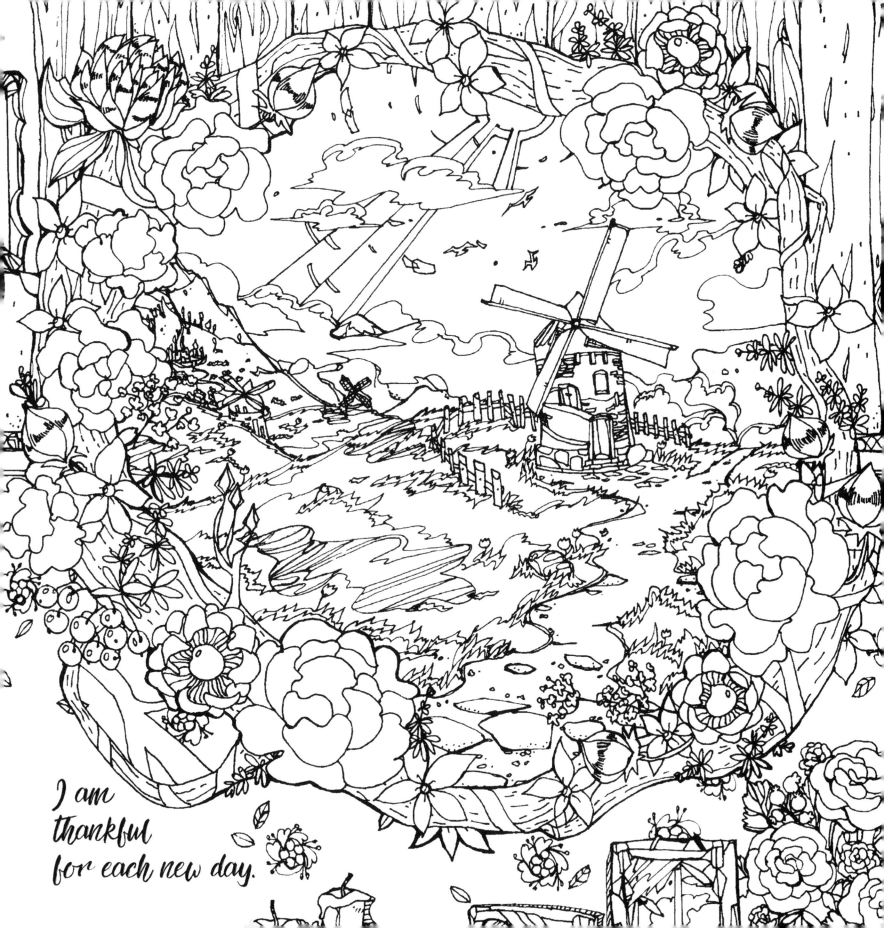

I am
thankful
for each new day.

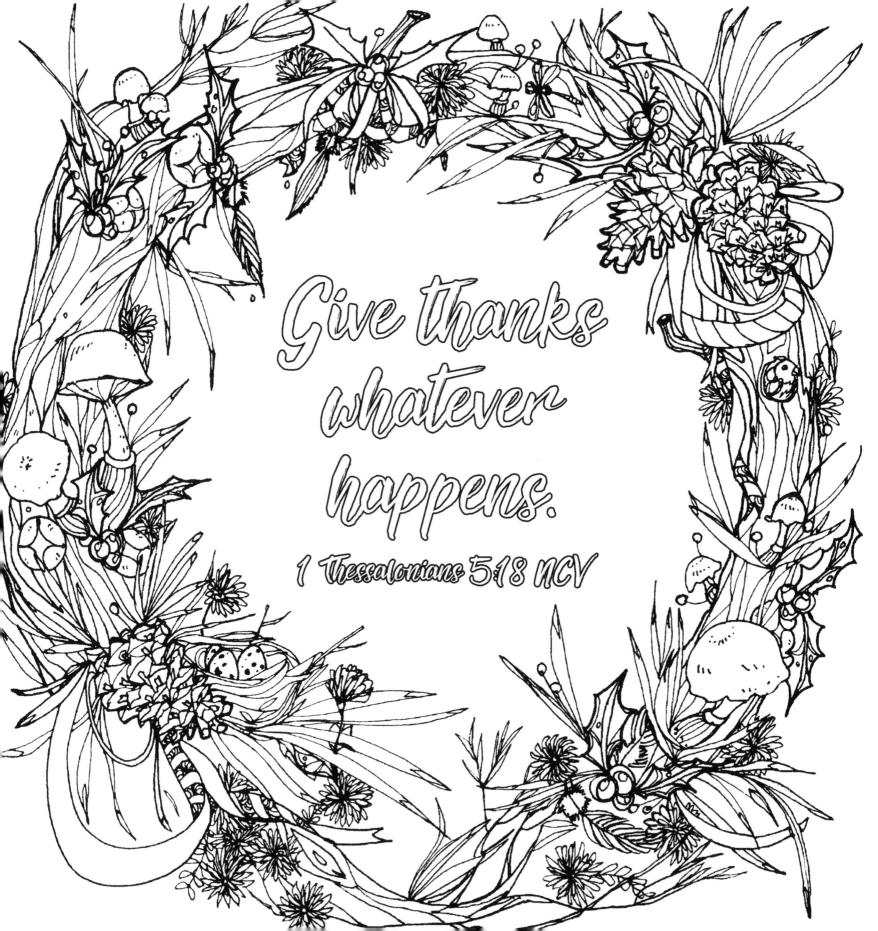

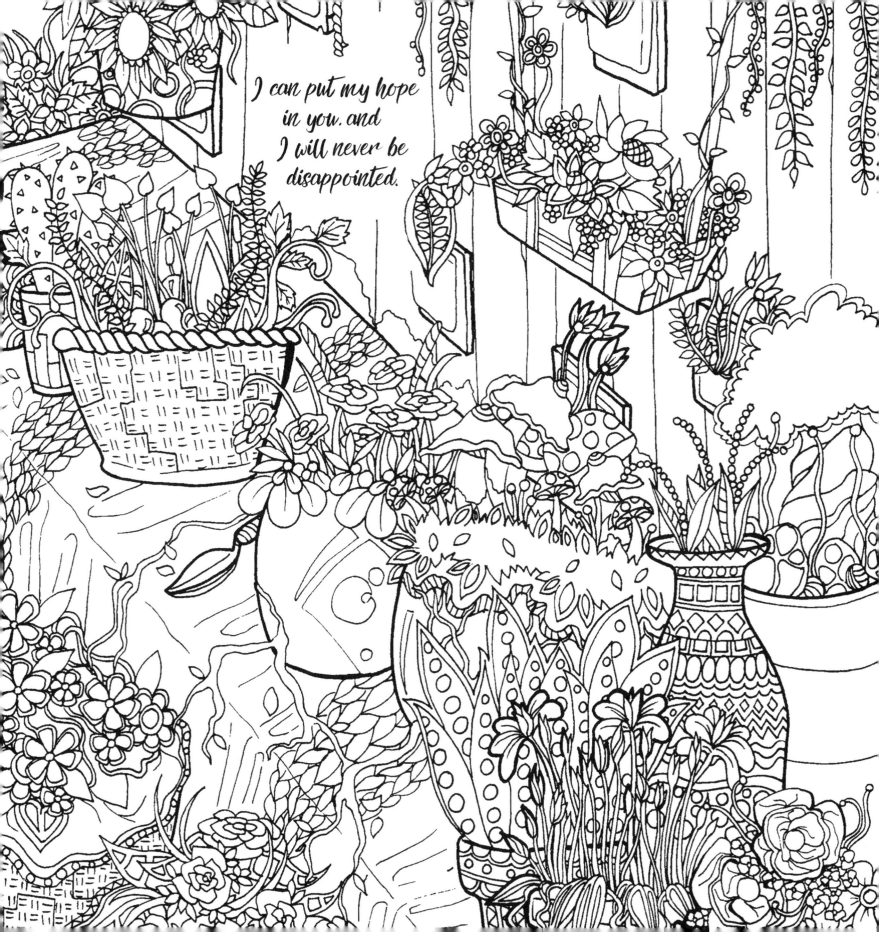

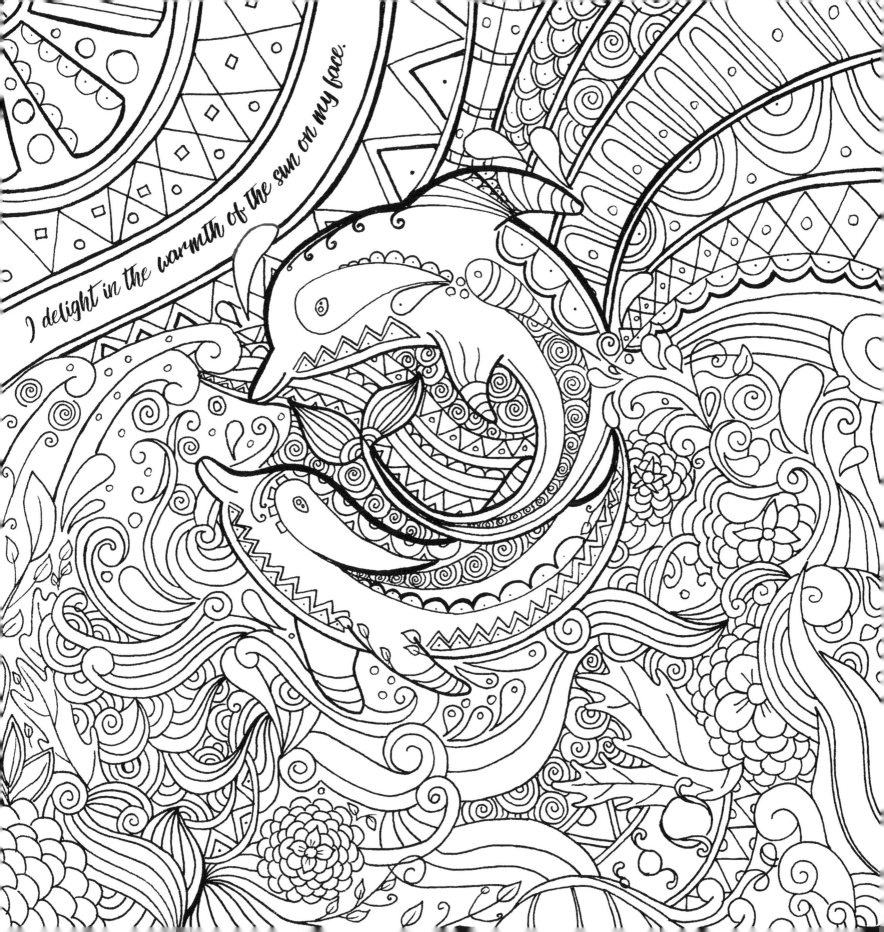

I delight in the warmth of the sun on my face.

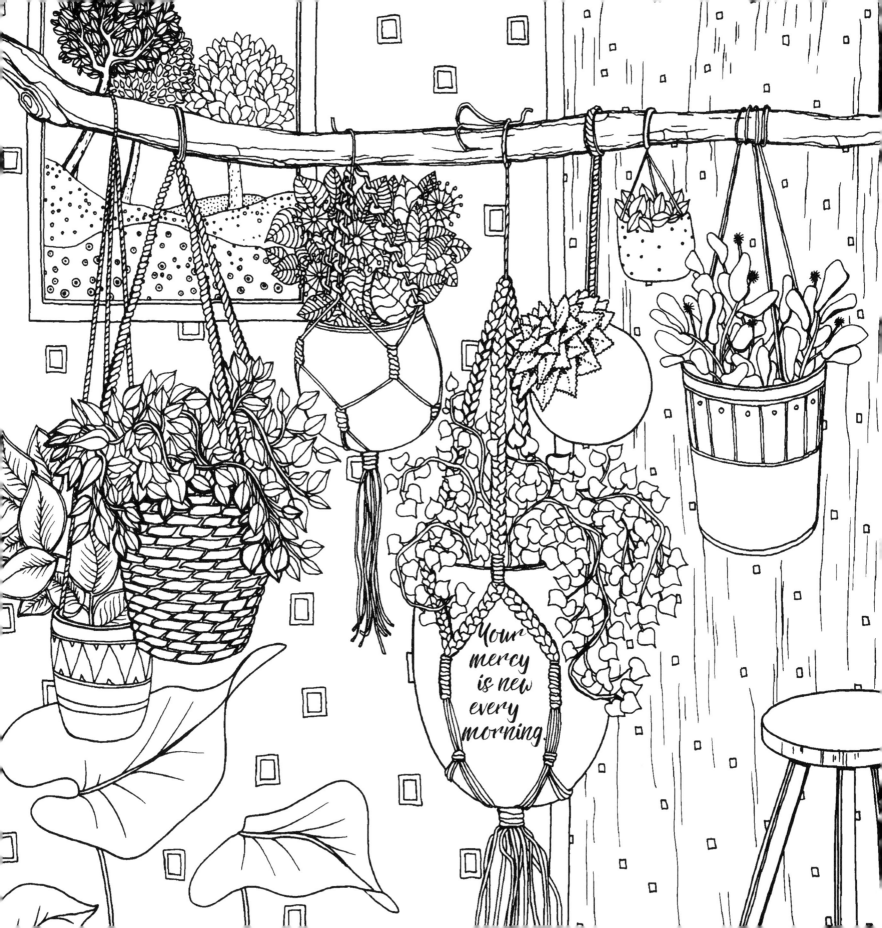

Your mercy is new every morning.

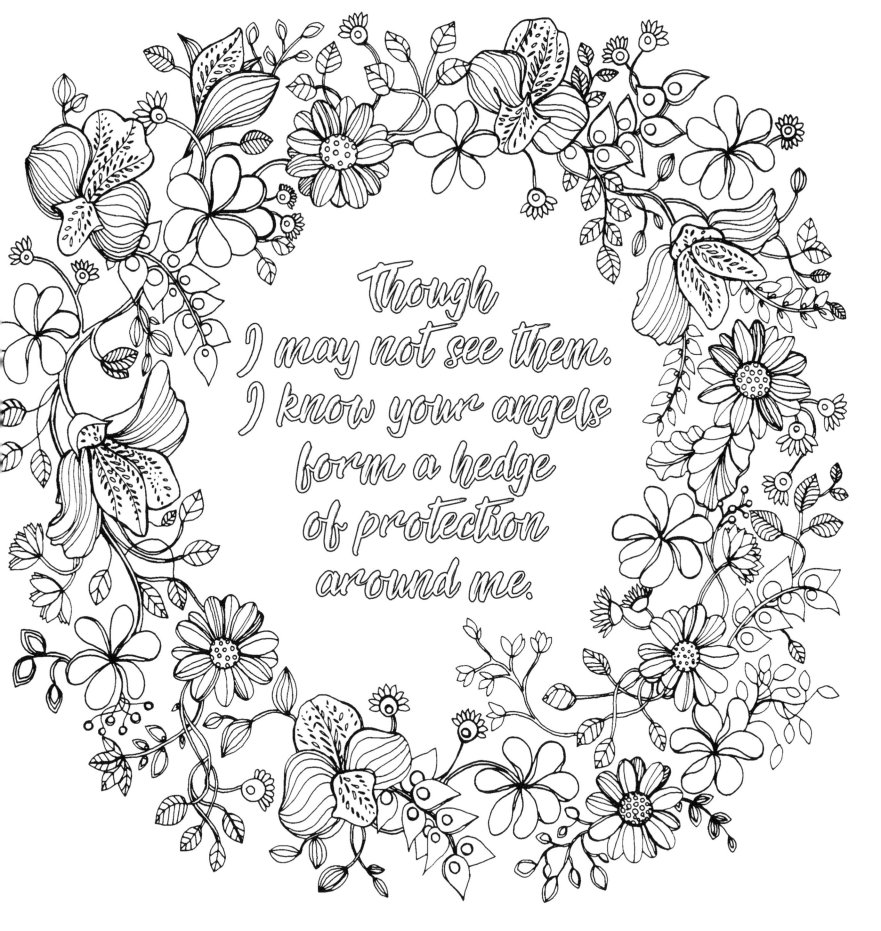

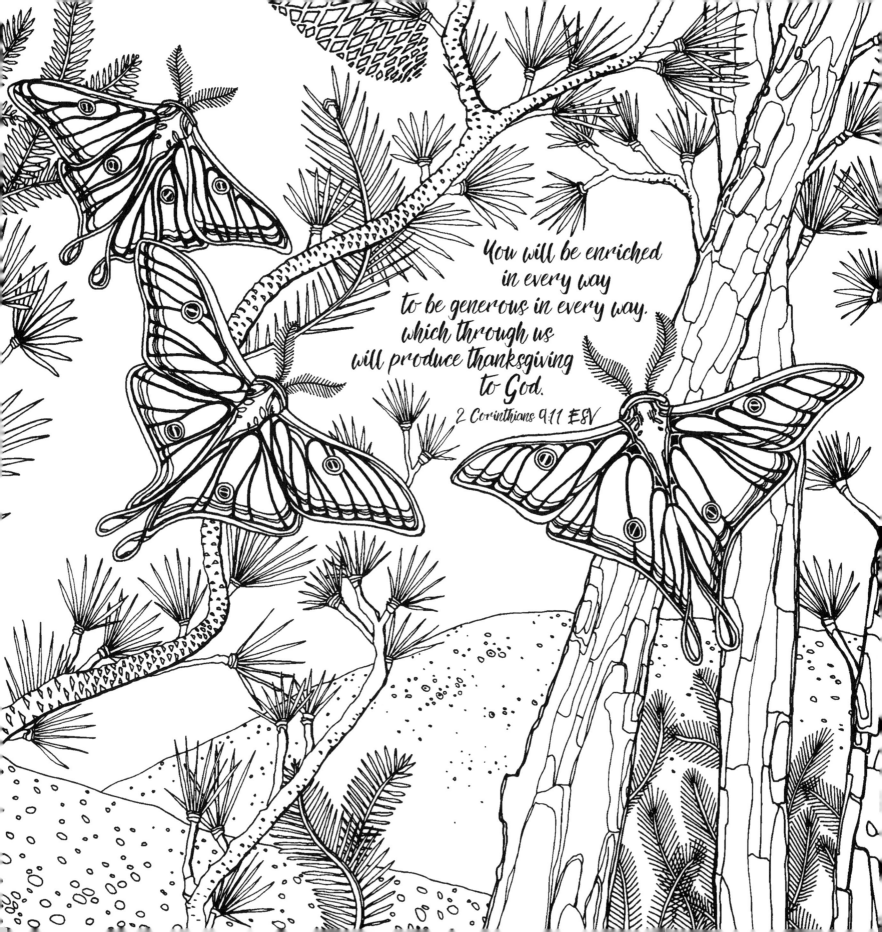

You will be enriched
in every way
to be generous in every way,
which through us
will produce thanksgiving
to God.

2 Corinthians 9:11 ESV

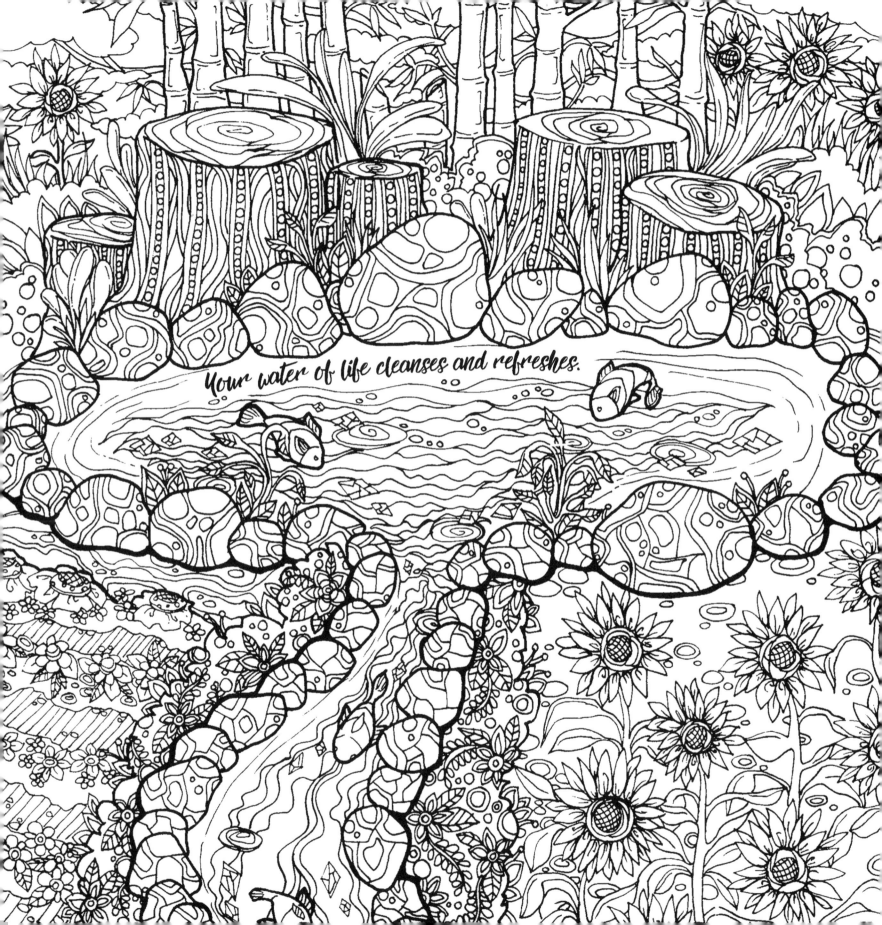

Your water of life cleanses and refreshes.

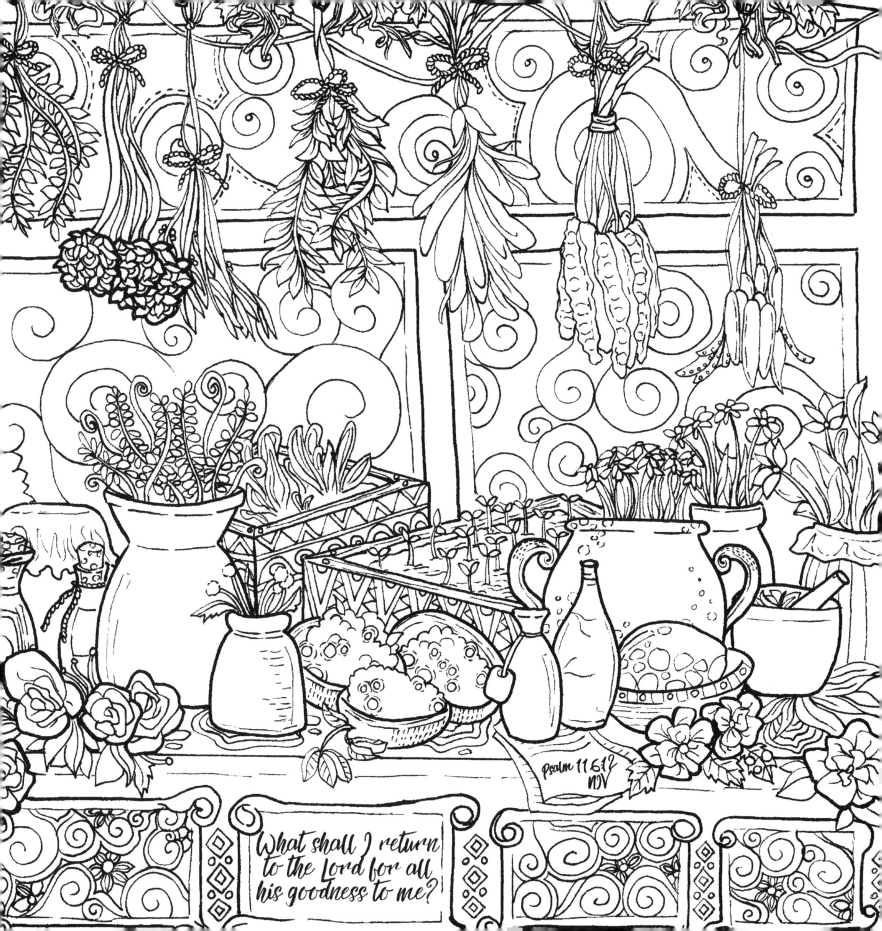

What shall I return to the Lord for all his goodness to me?

Psalm 116:12 NIV

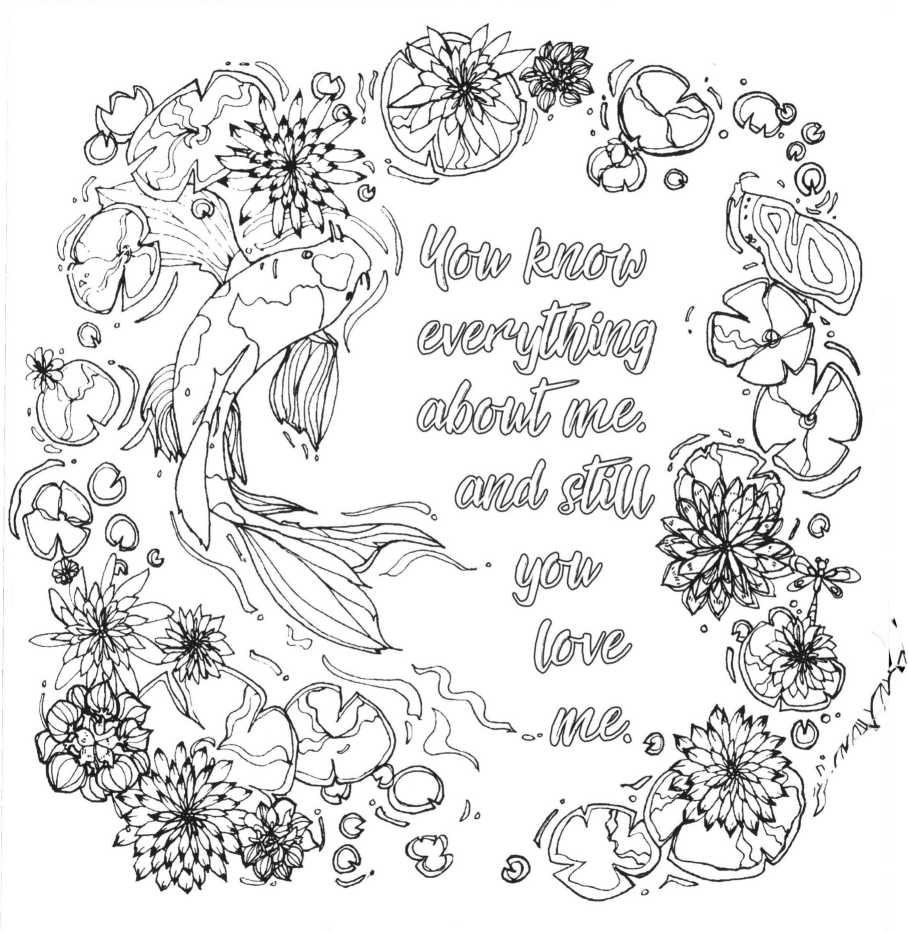

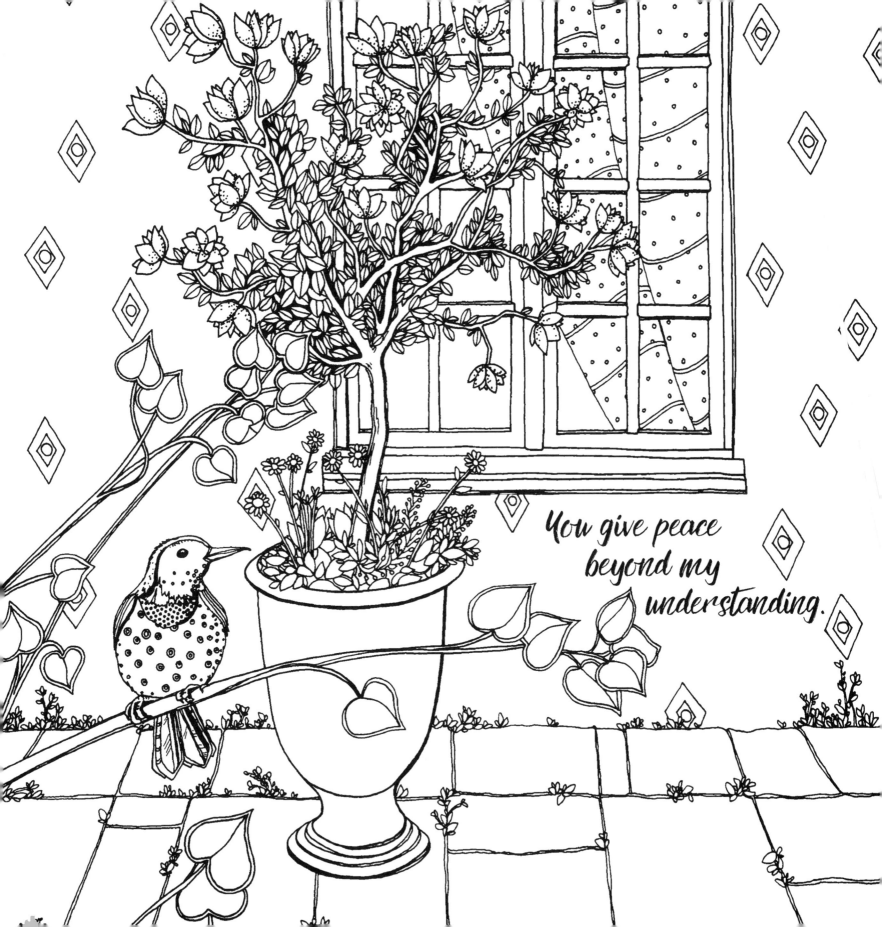

You give peace
beyond my
understanding.

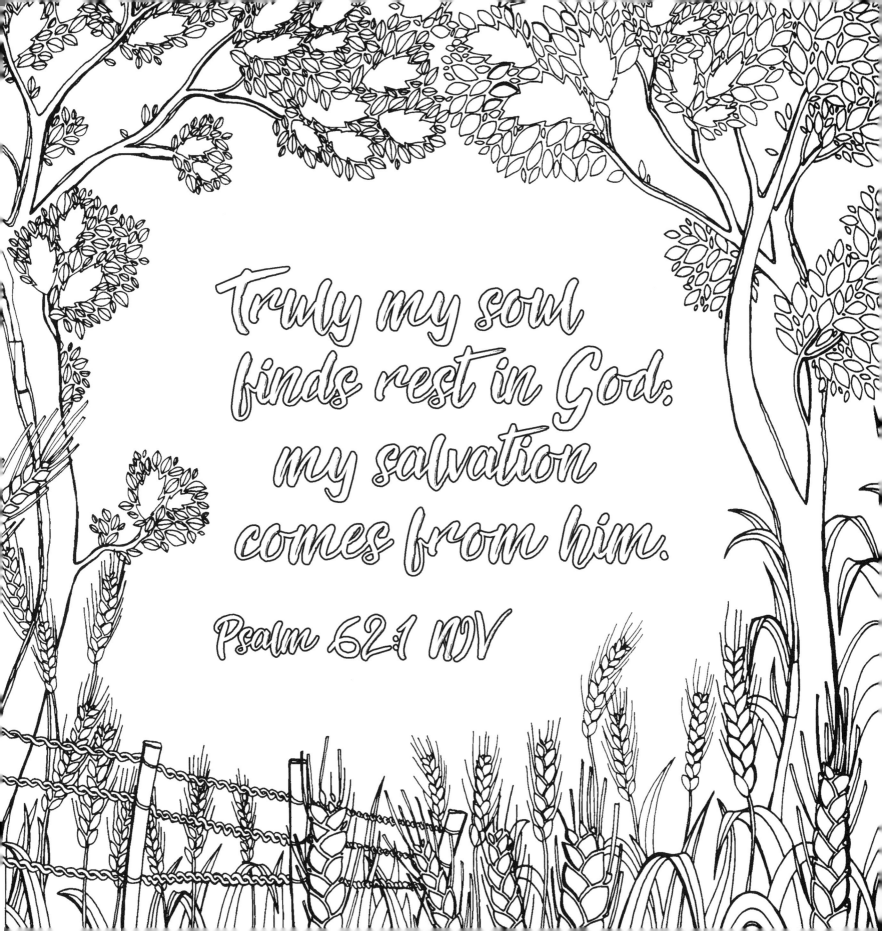

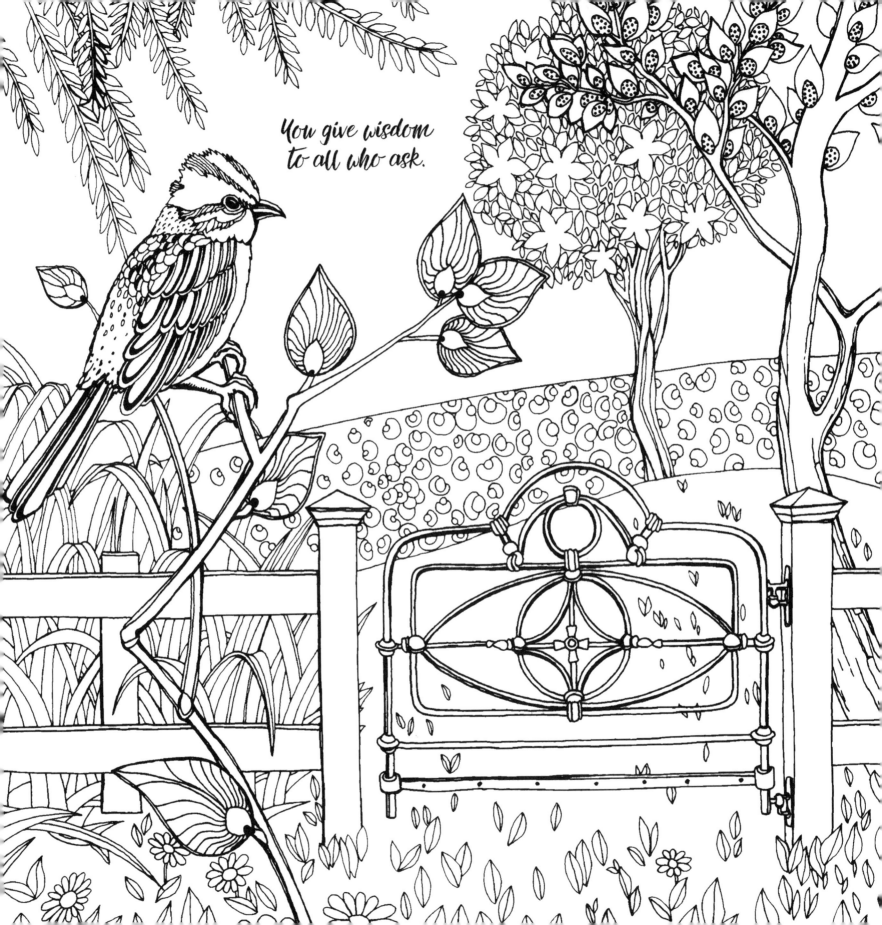

You give wisdom
to all who ask.

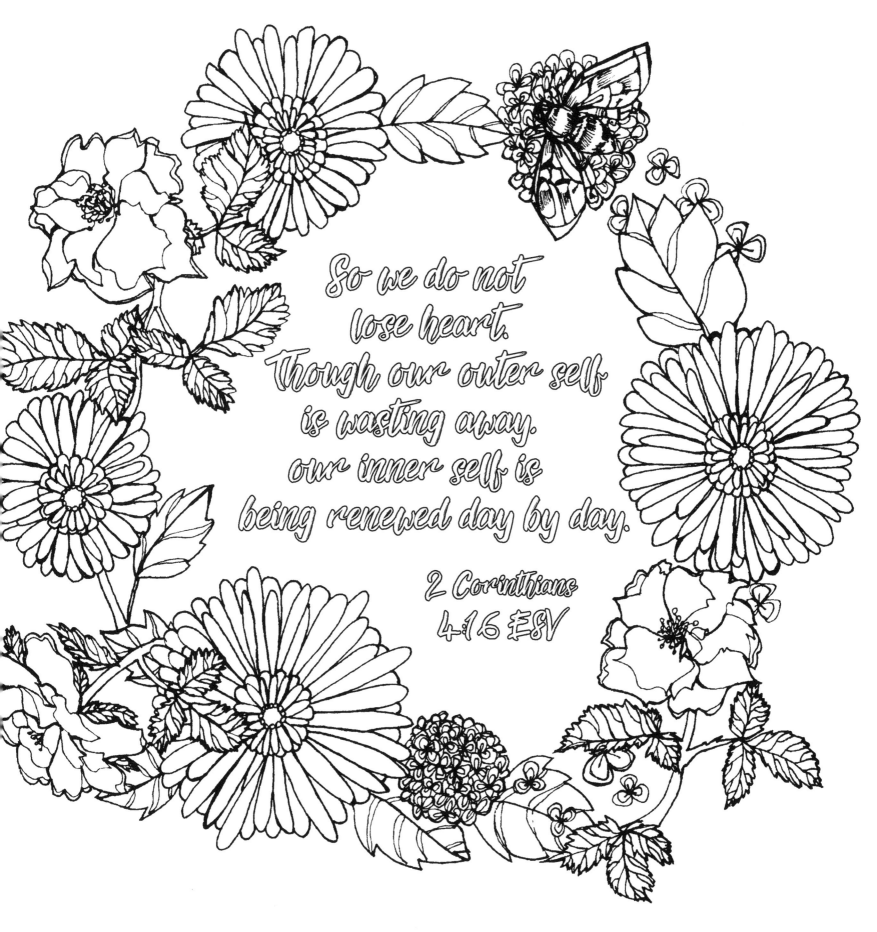

So we do not
lose heart.
Though our outer self
is wasting away,
our inner self is
being renewed day by day.

2 Corinthians
4:16 ESV

I am never alone because you are with me.

Whatever you do,
in word or deed, do everything
in the name of the Lord Jesus,
giving thanks to God the Father
through him.

Colossians 3:17 NRSV

Walking in freedom means I can leave my past behind and fully embrace the future.

Since we are receiving
a kingdom
that cannot be shaken.
let us be thankful.
and so worship God
acceptably with reverence
and awe.

Hebrews 12:28 NIV

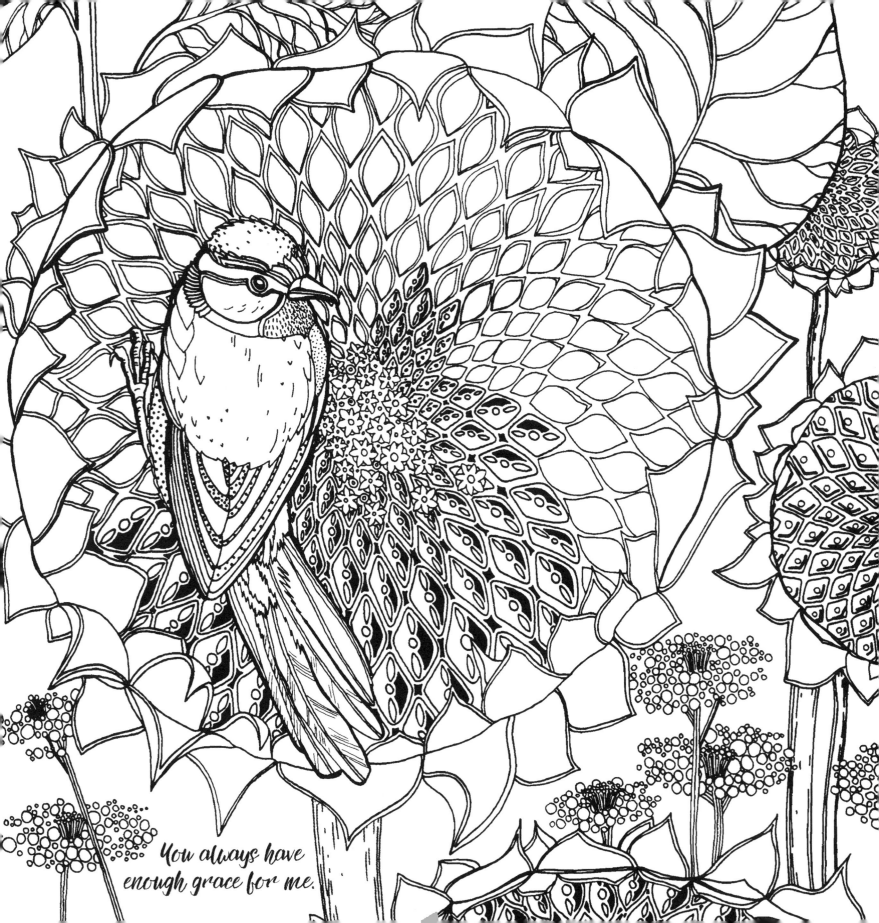

You always have
enough grace for me.

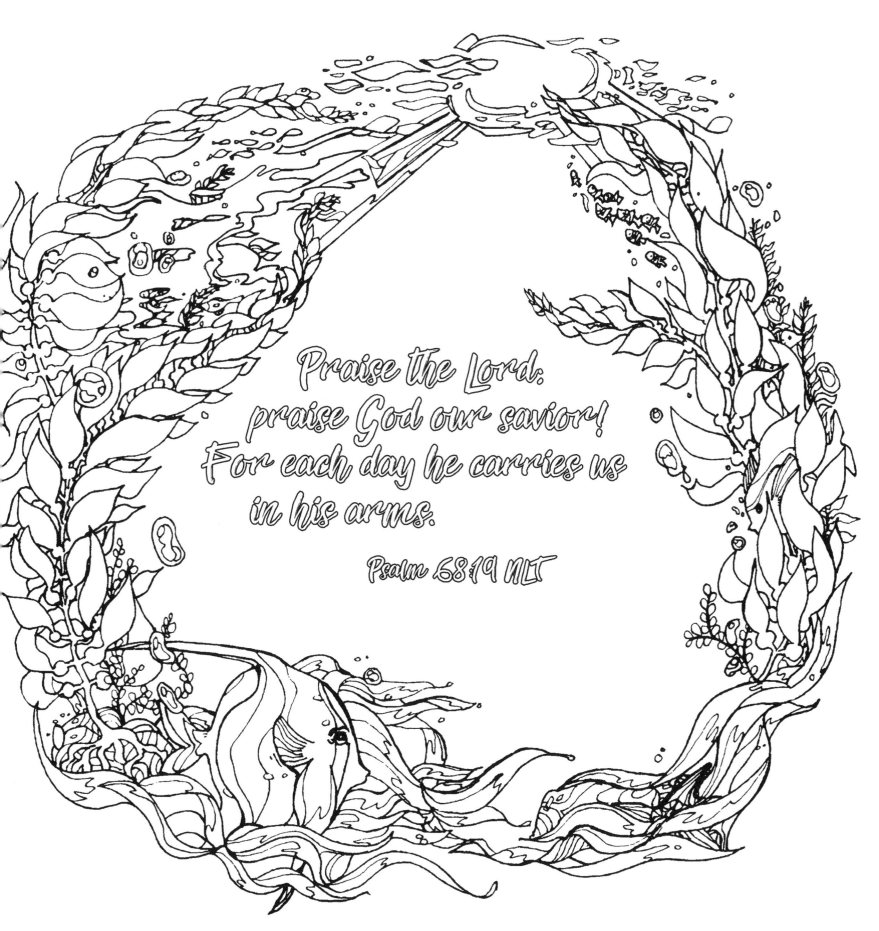

Praise the Lord;
praise God our savior!
For each day he carries us
in his arms.

Psalm 68:19 NLT

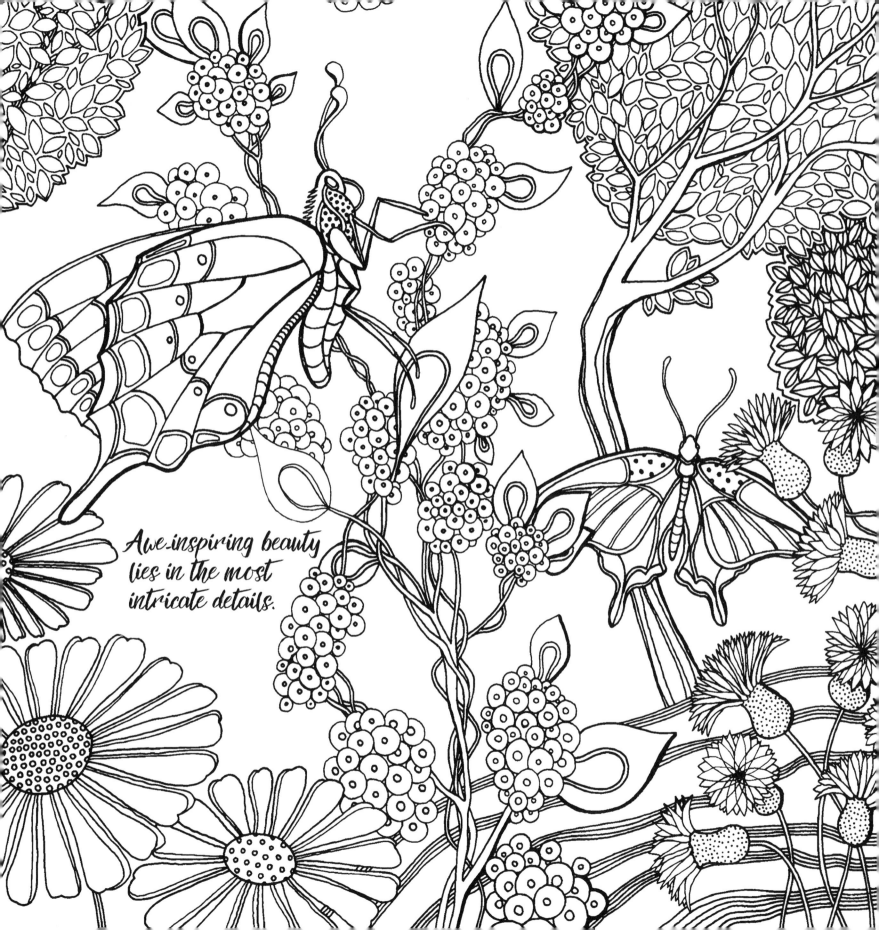

Awe-inspiring beauty lies in the most intricate details.

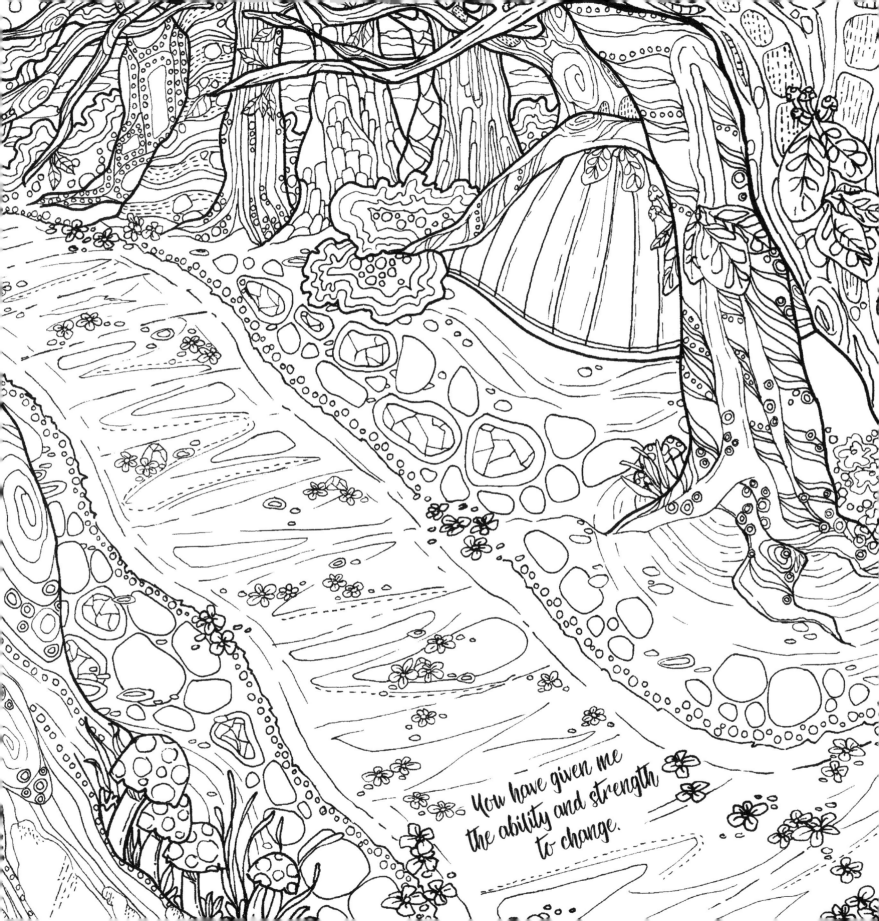

You have given me the ability and strength to change.

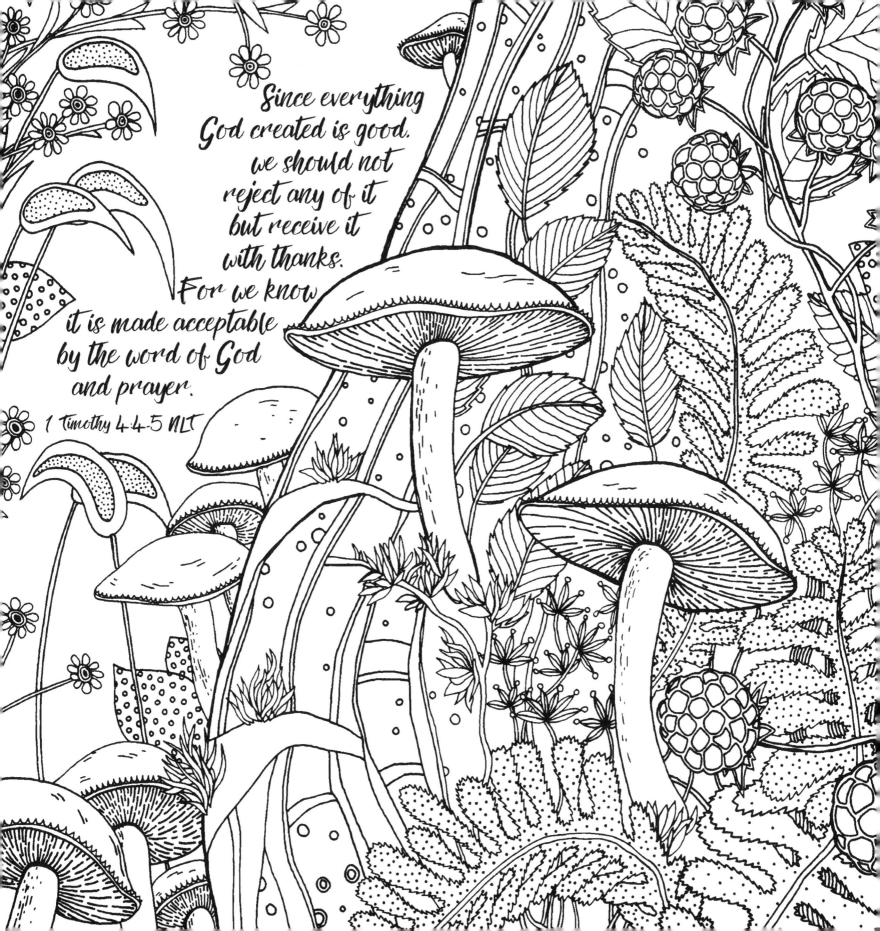

Since everything God created is good, we should not reject any of it but receive it with thanks. For we know it is made acceptable by the word of God and prayer.

1 Timothy 4:4-5 NLT

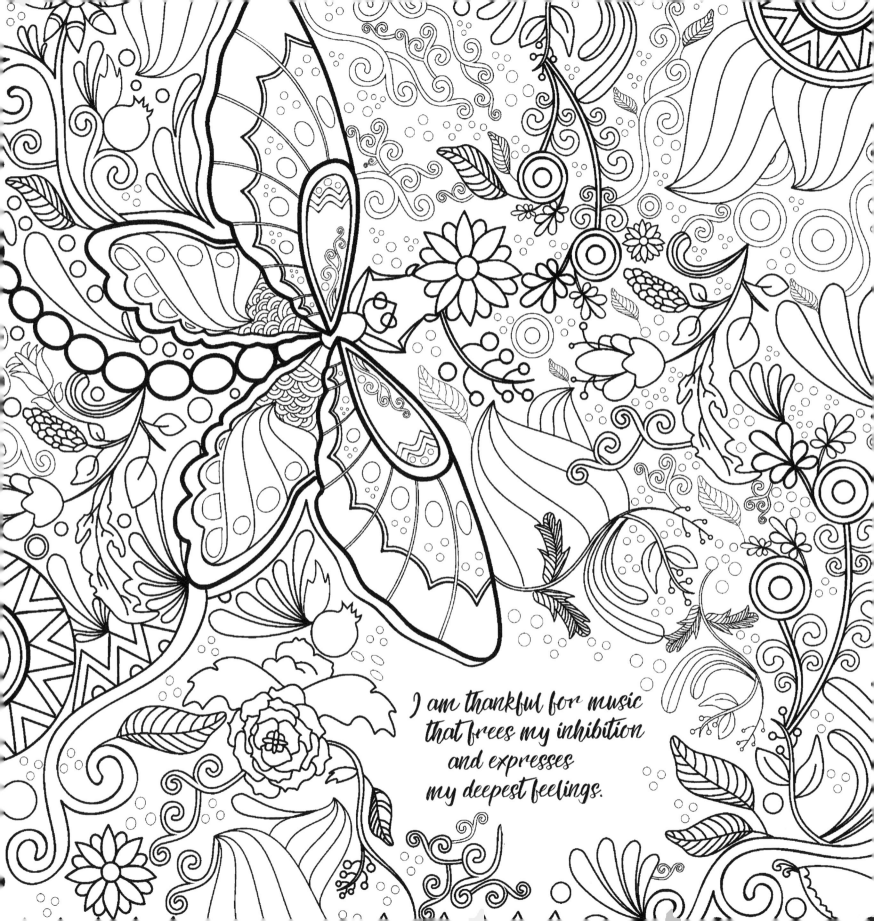

I am thankful for music
that frees my inhibition
and expresses
my deepest feelings.

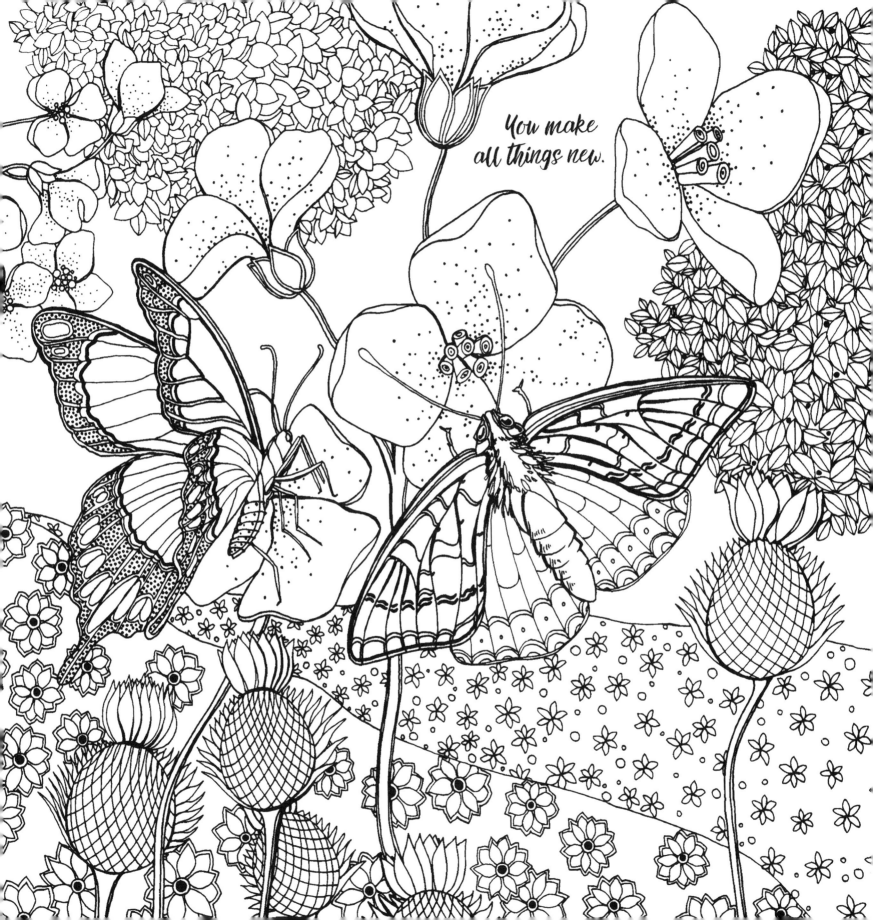

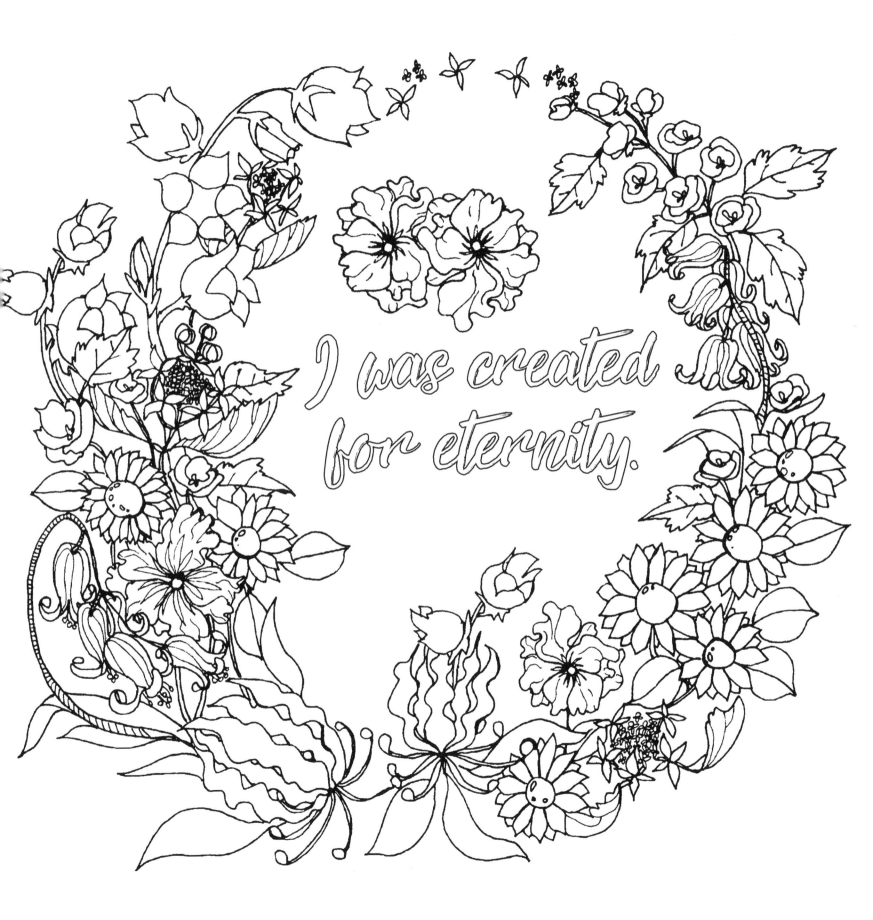

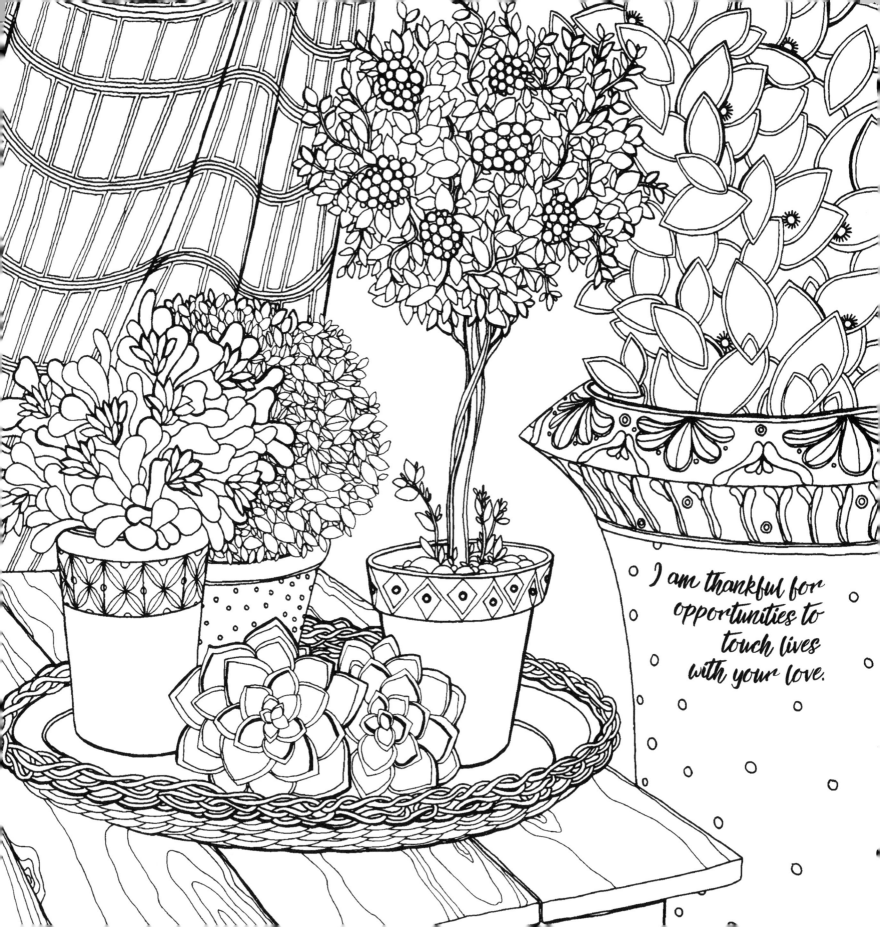

I am thankful for
opportunities to
touch lives
with your love.

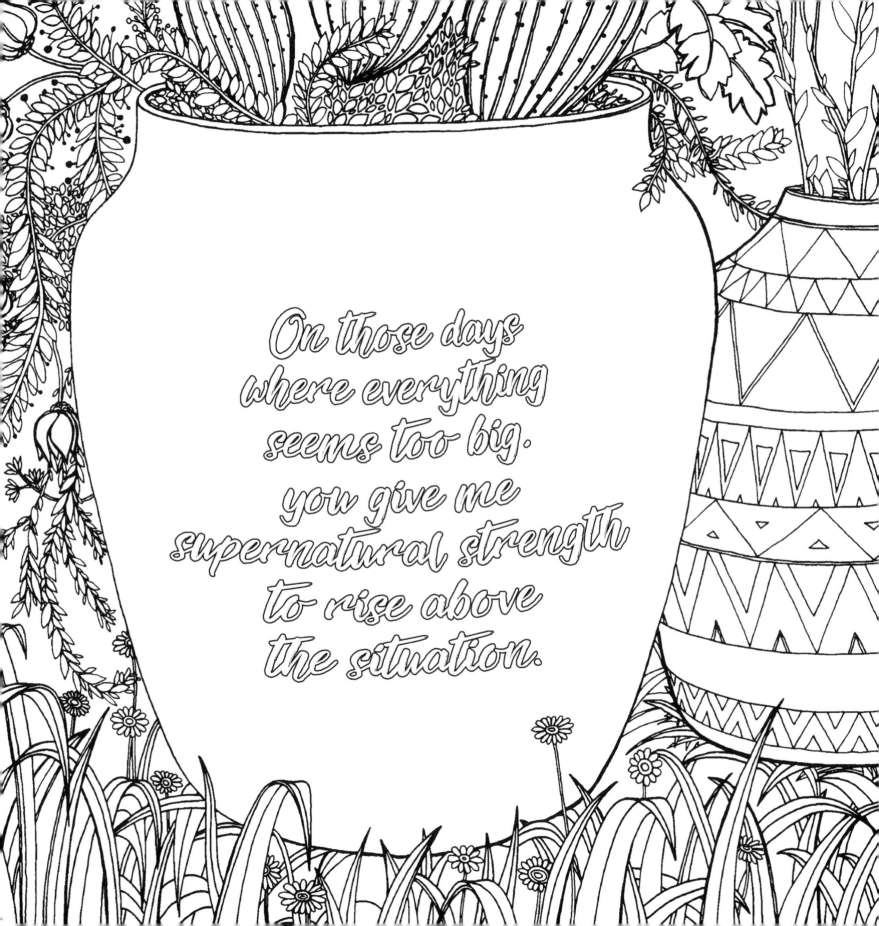

On those days
where everything
seems too big,
you give me
supernatural strength
to rise above
the situation.

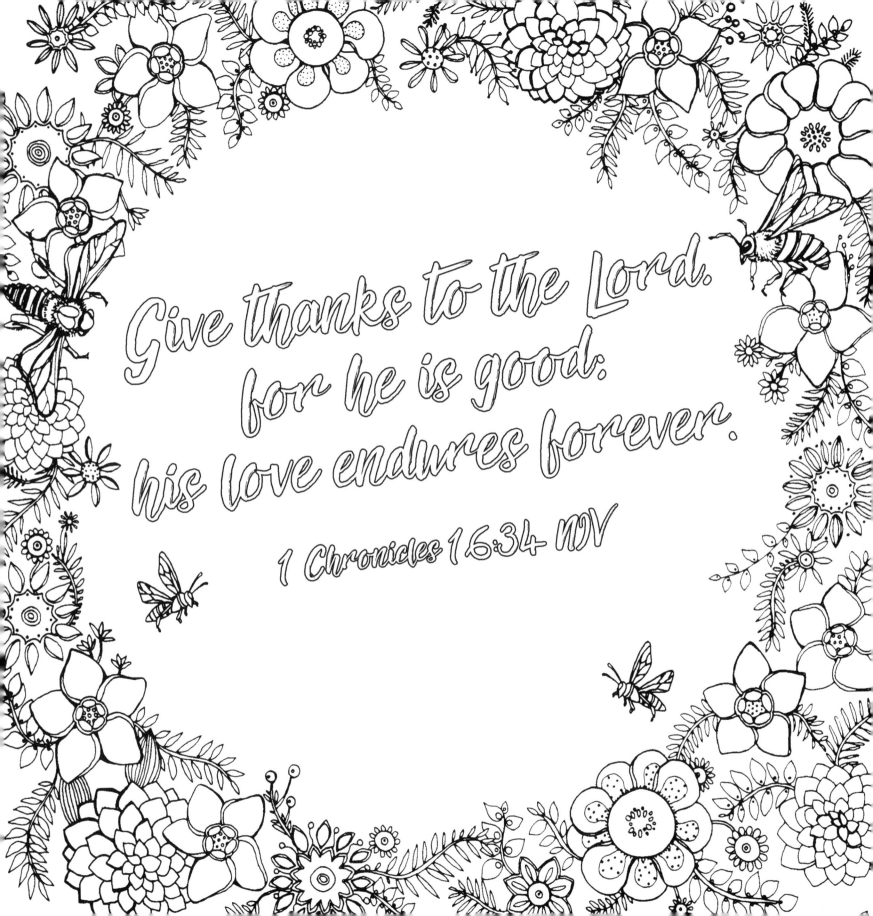

Give thanks to the Lord, for he is good; his love endures forever.

1 Chronicles 16:34 NIV

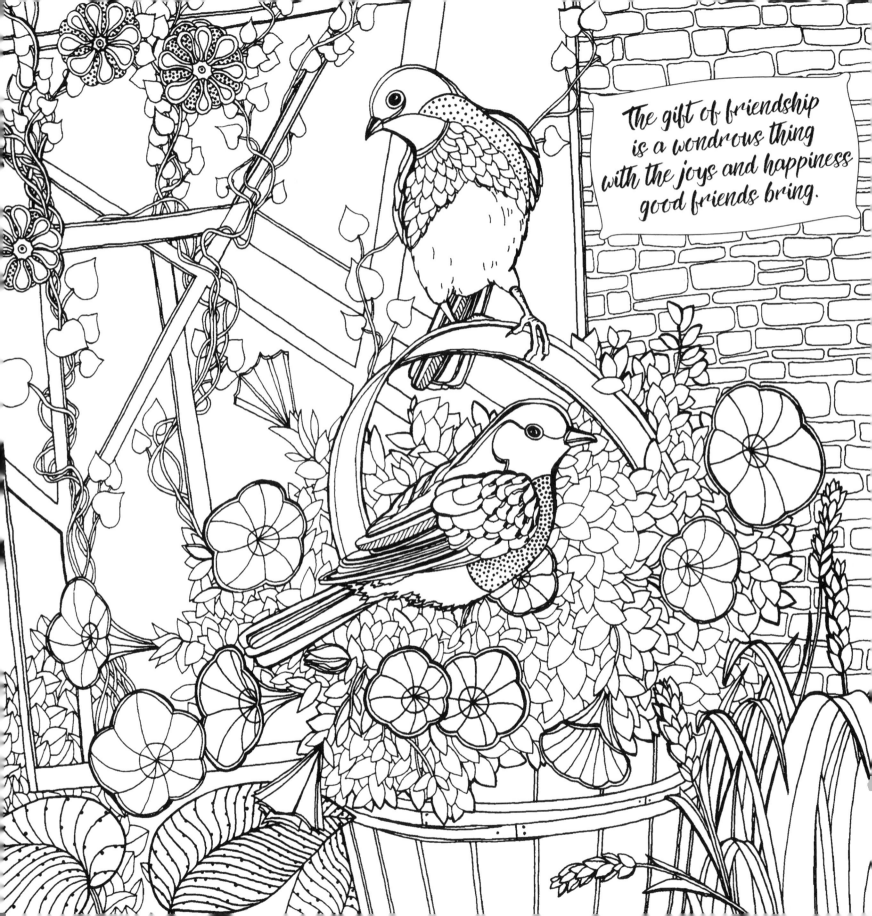

The gift of friendship
is a wondrous thing
with the joys and happiness
good friends bring.

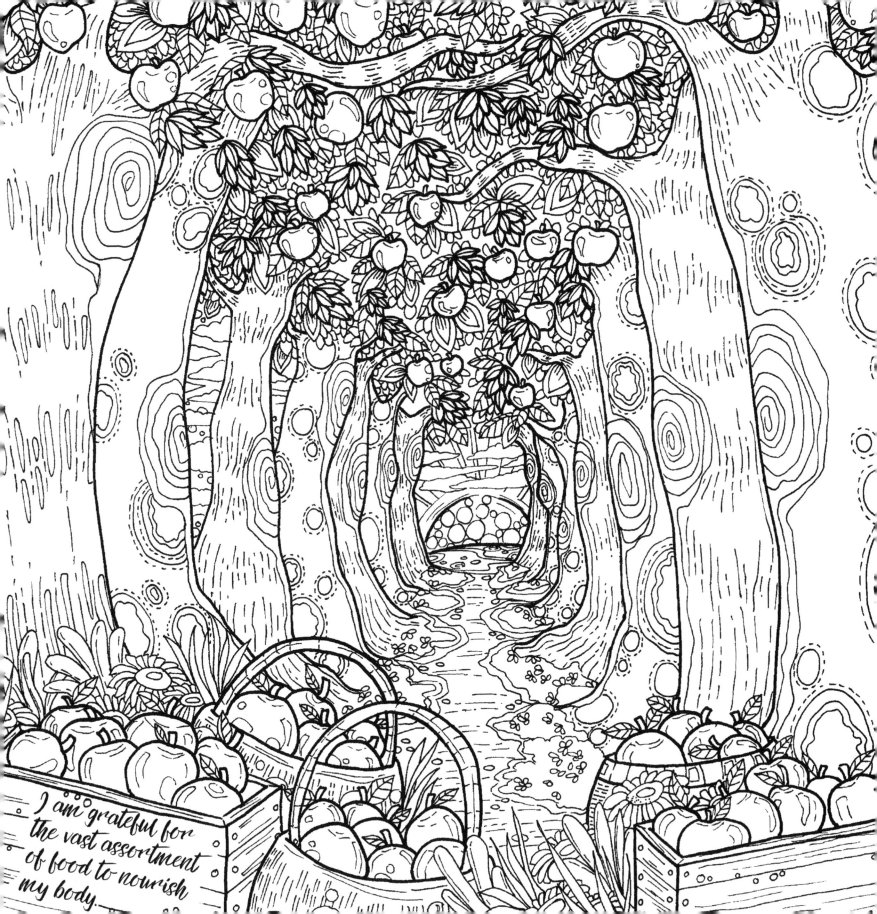

I am grateful for the vast assortment of food to nourish my body.

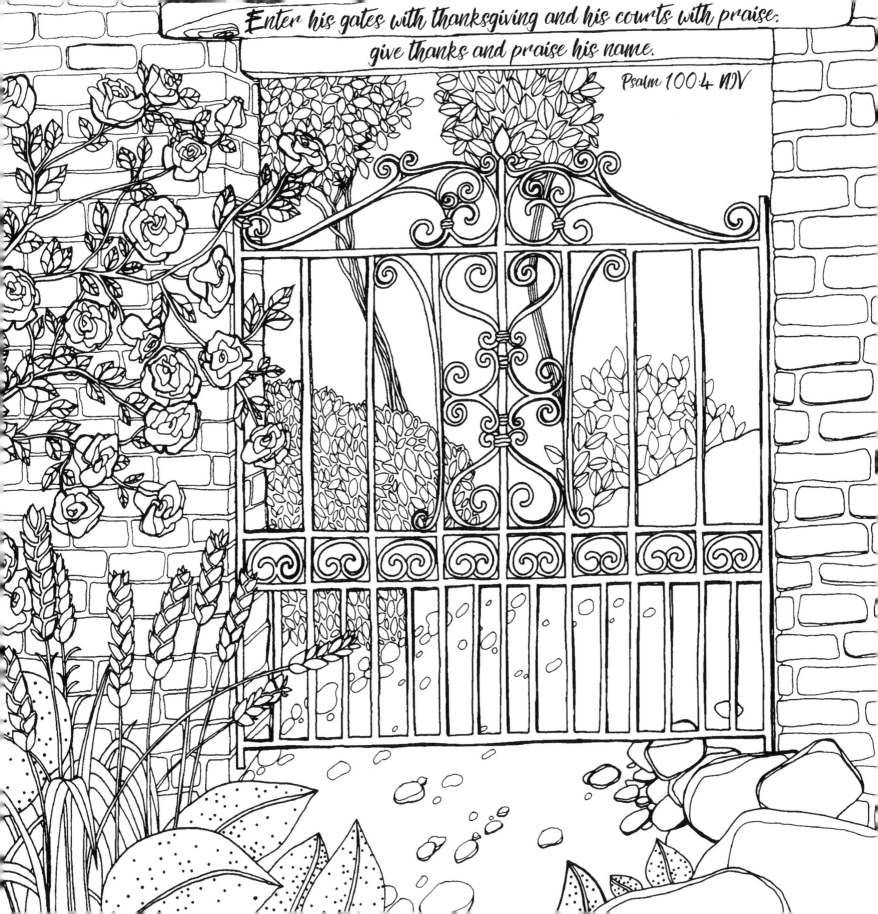

Enter his gates with thanksgiving and his courts with praise:
give thanks and praise his name.

Psalm 100:4 NIV

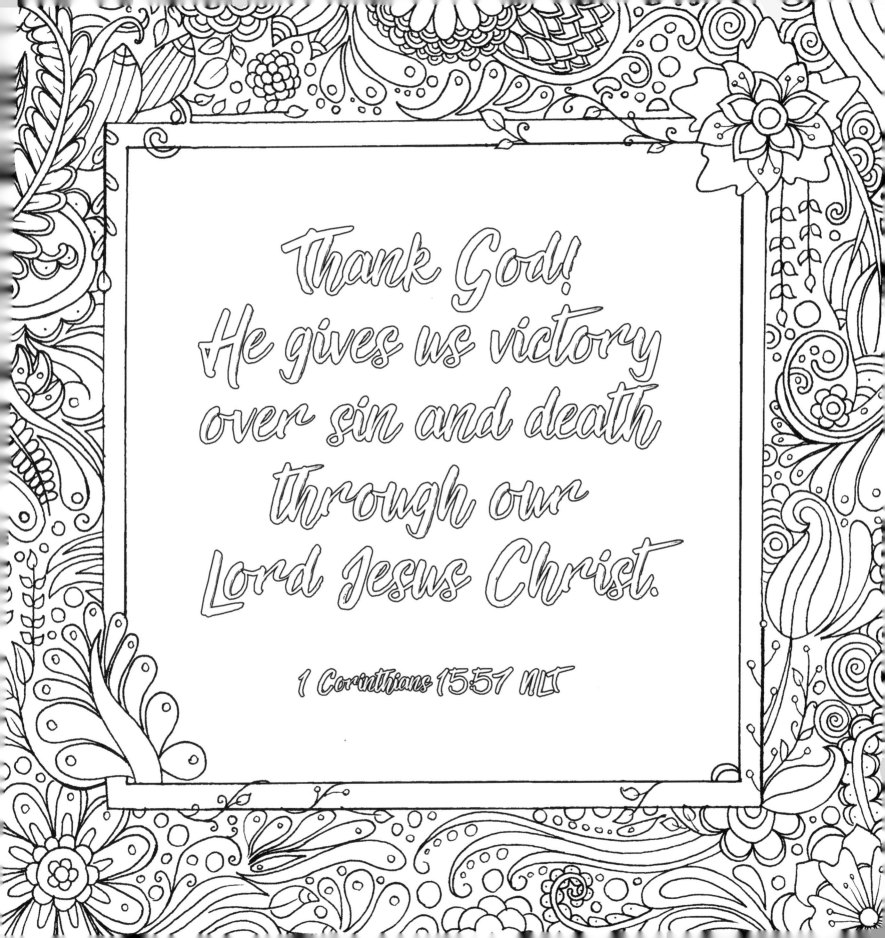

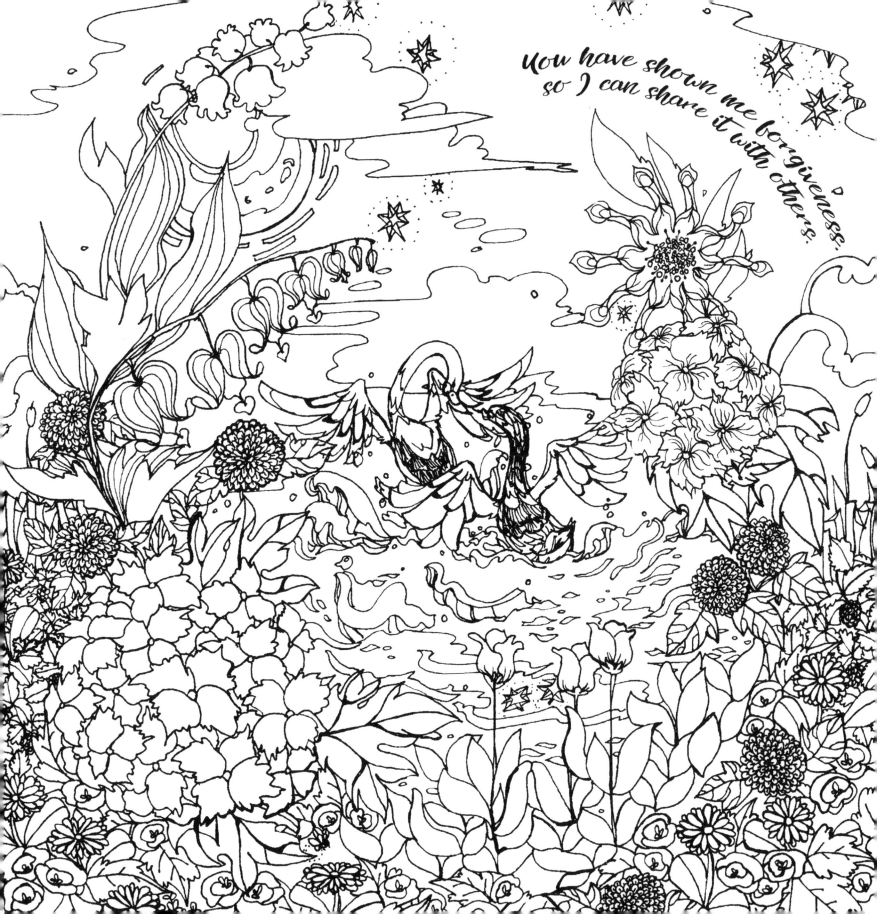

You have shown me forgiveness, so I can share it with others.

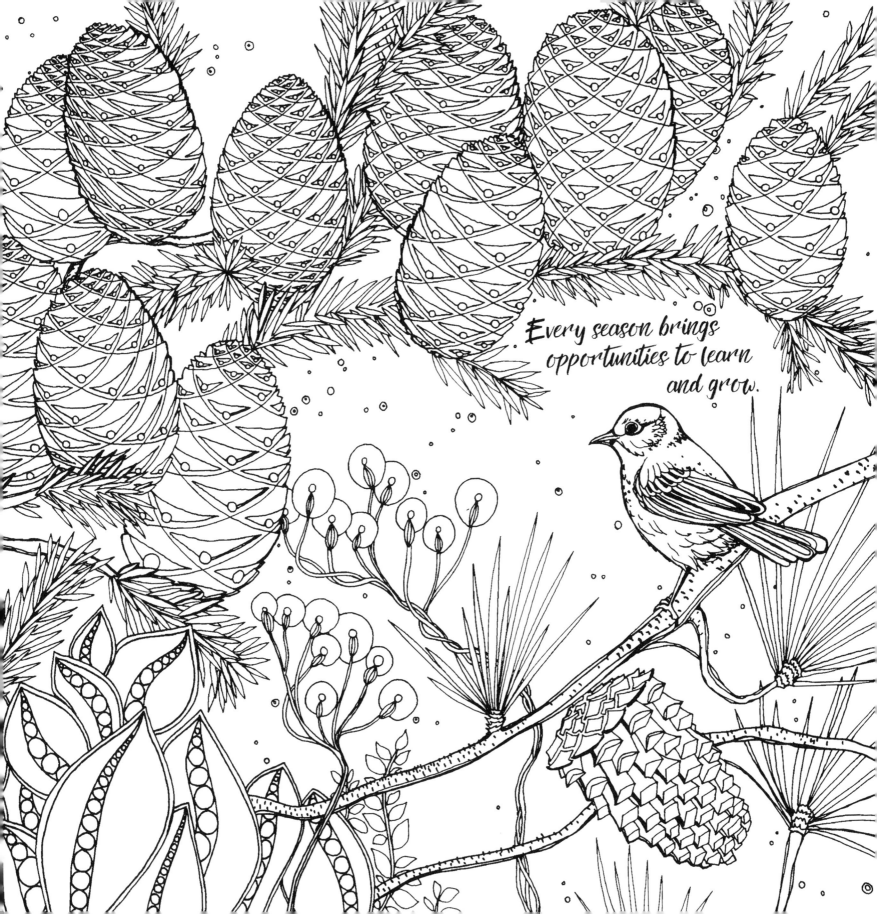

Every season brings
opportunities to learn
and grow.

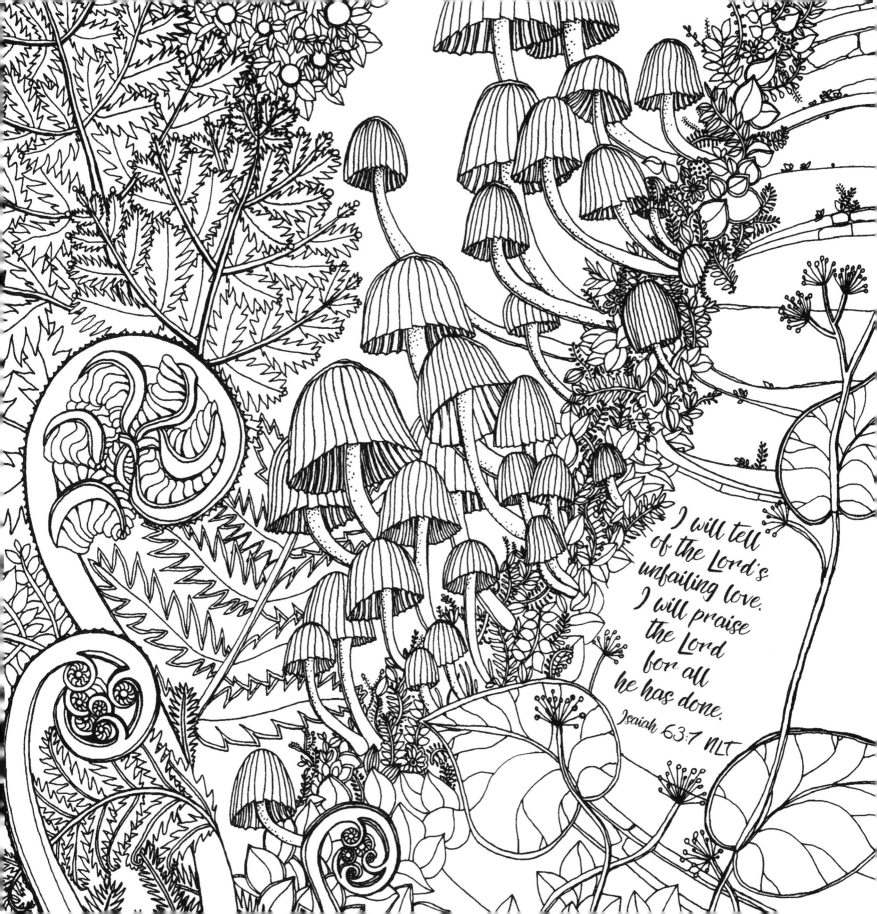

I will tell
of the Lord's
unfailing love.
I will praise
the Lord
for all
he has done.

Isaiah 63:7 NLT

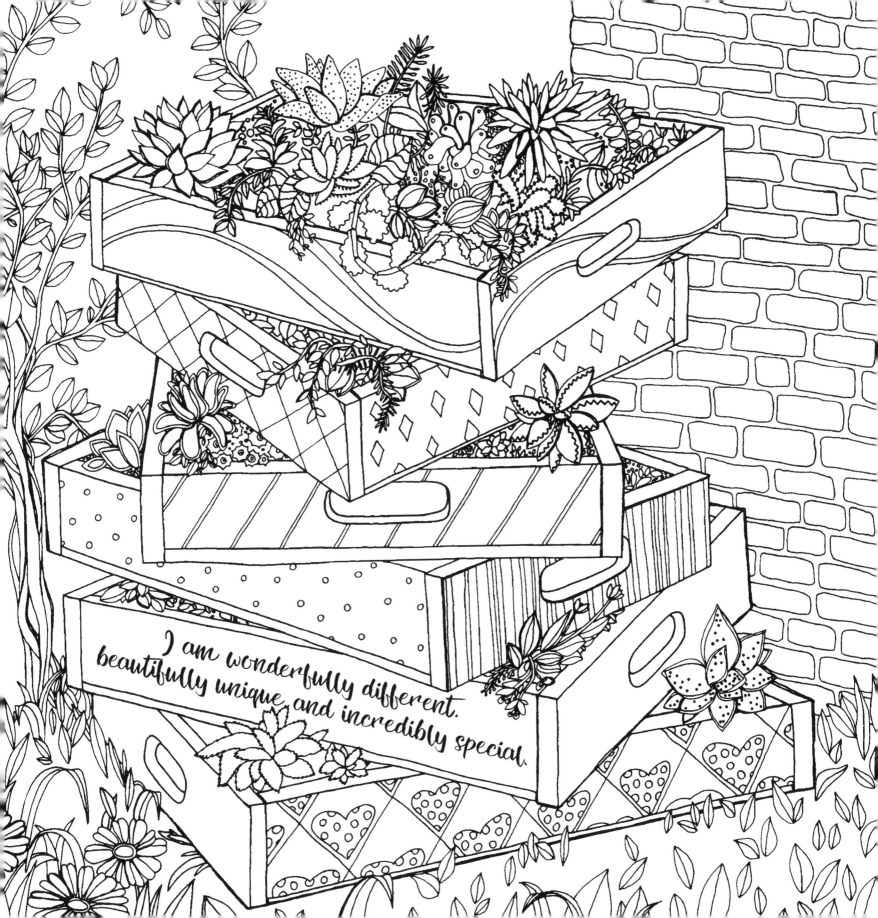

I am wonderfully different, beautifully unique, and incredibly special.

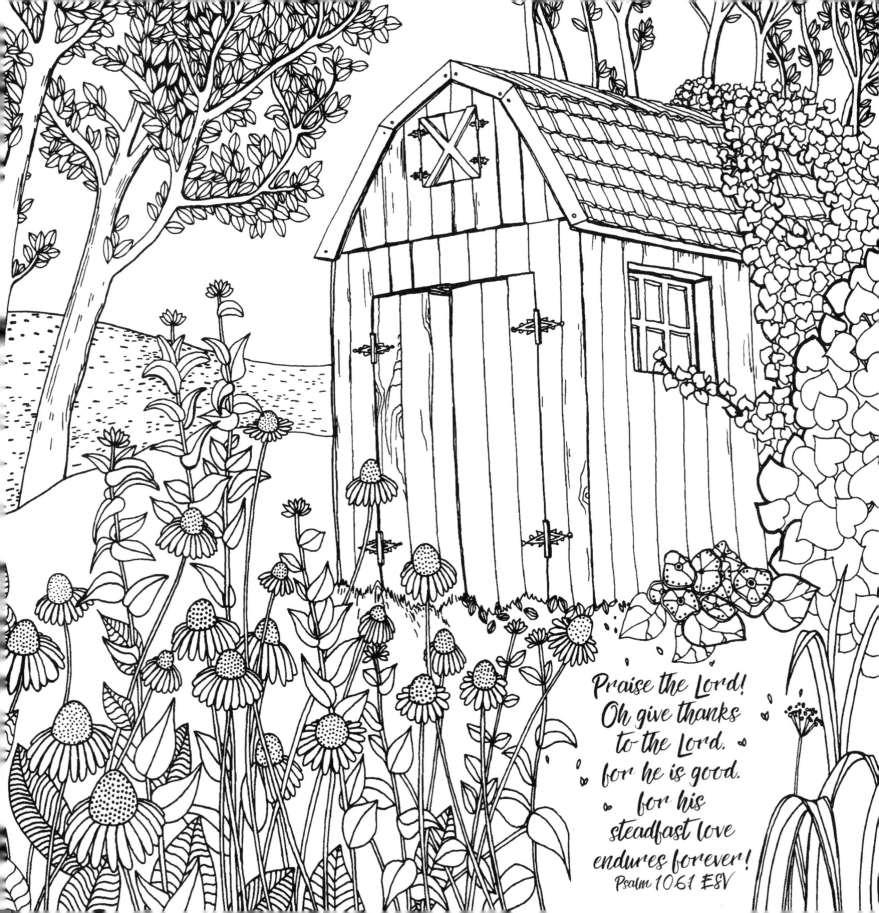

Praise the Lord!
Oh give thanks
to the Lord.
for he is good.
for his
steadfast love
endures forever!
Psalm 106:1 ESV

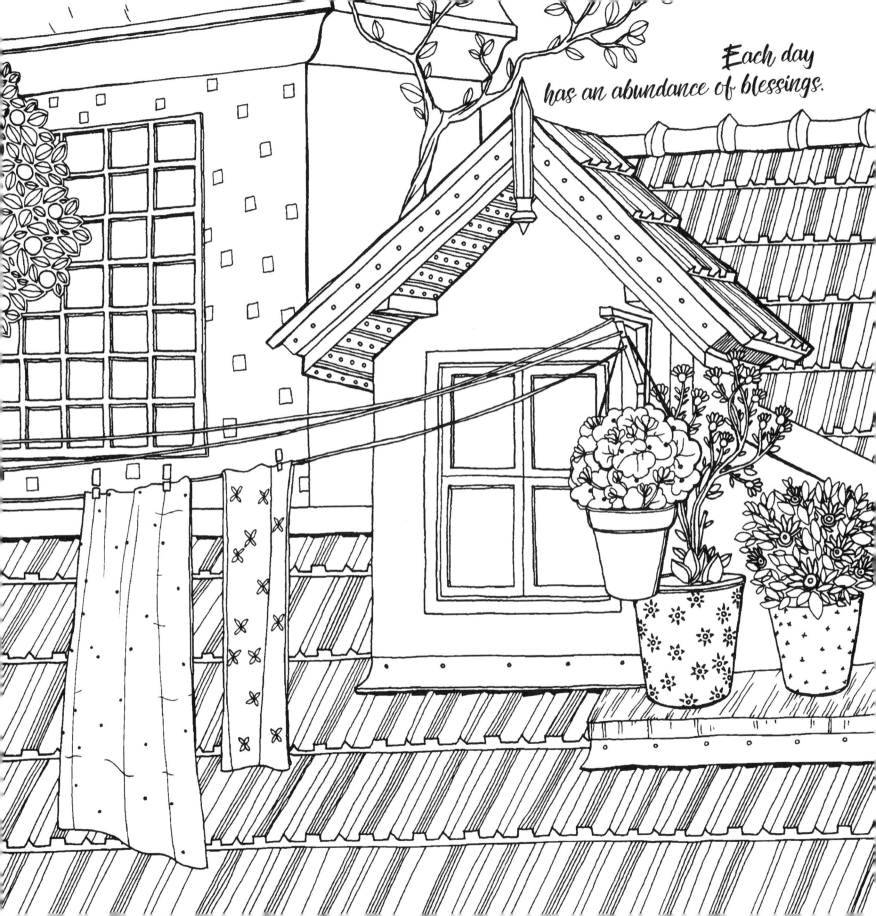

Each day
has an abundance of blessings.

The Lord is my strength
and my shield.
my heart trusts in Him.
and I am helped.
therefore my heart exults.
and with my song
I shall thank Him.

Psalm 28:7 NASB

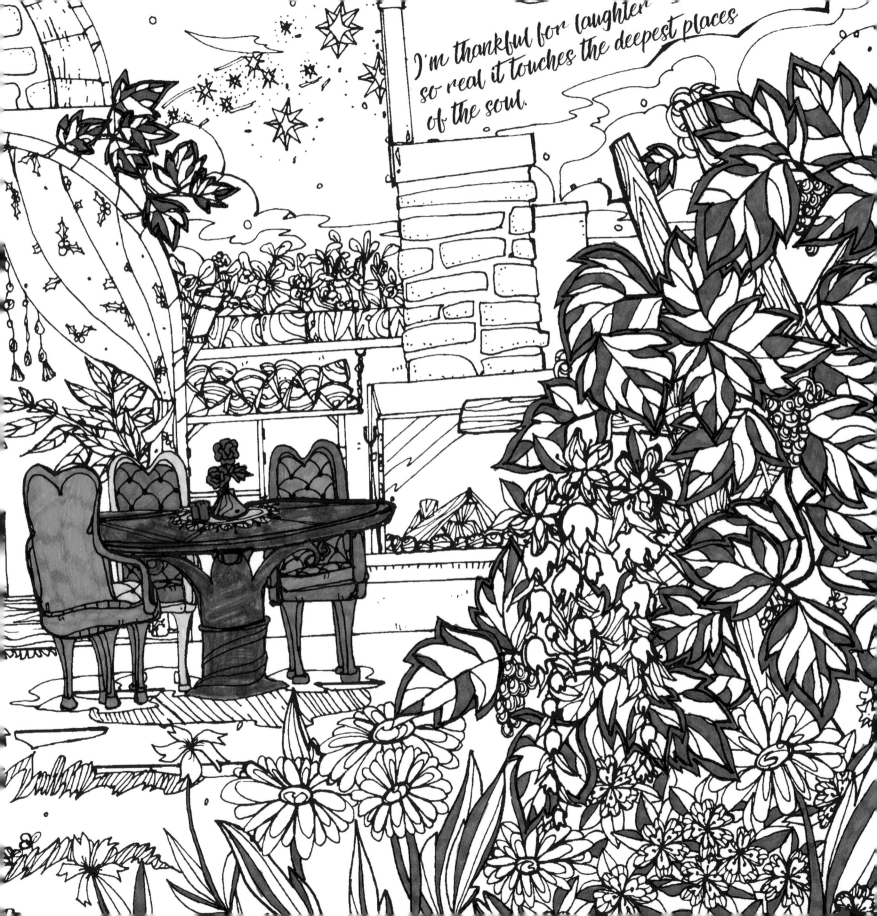

I'm thankful for laughter so real it touches the deepest places of the soul.

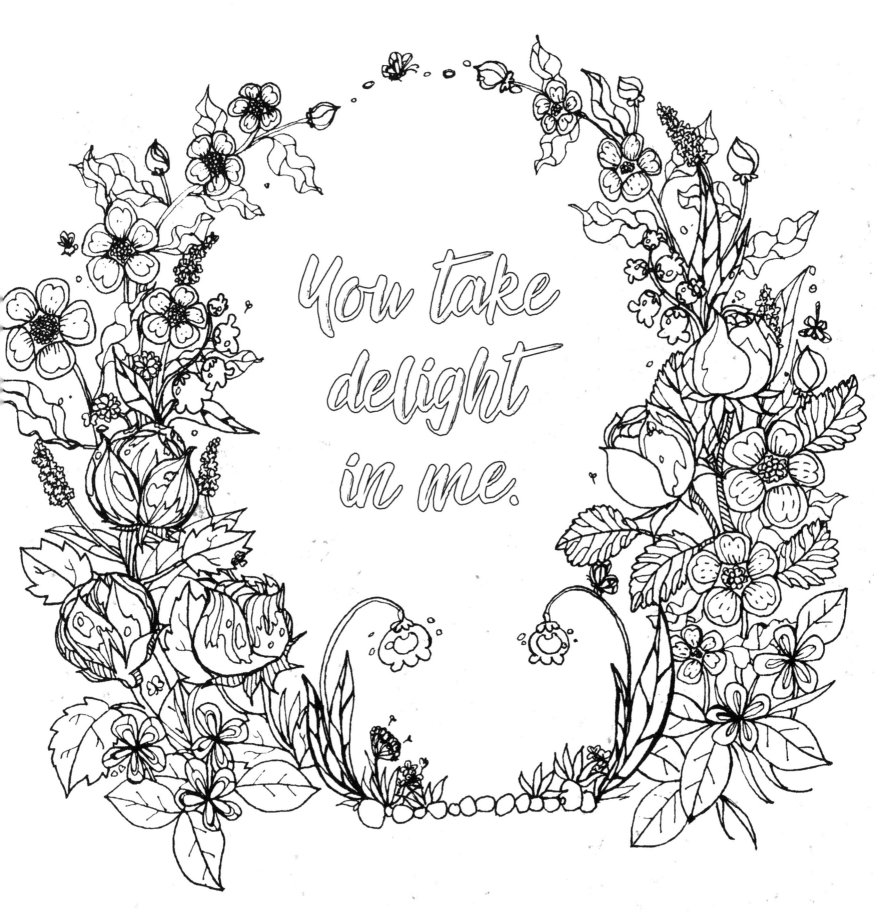

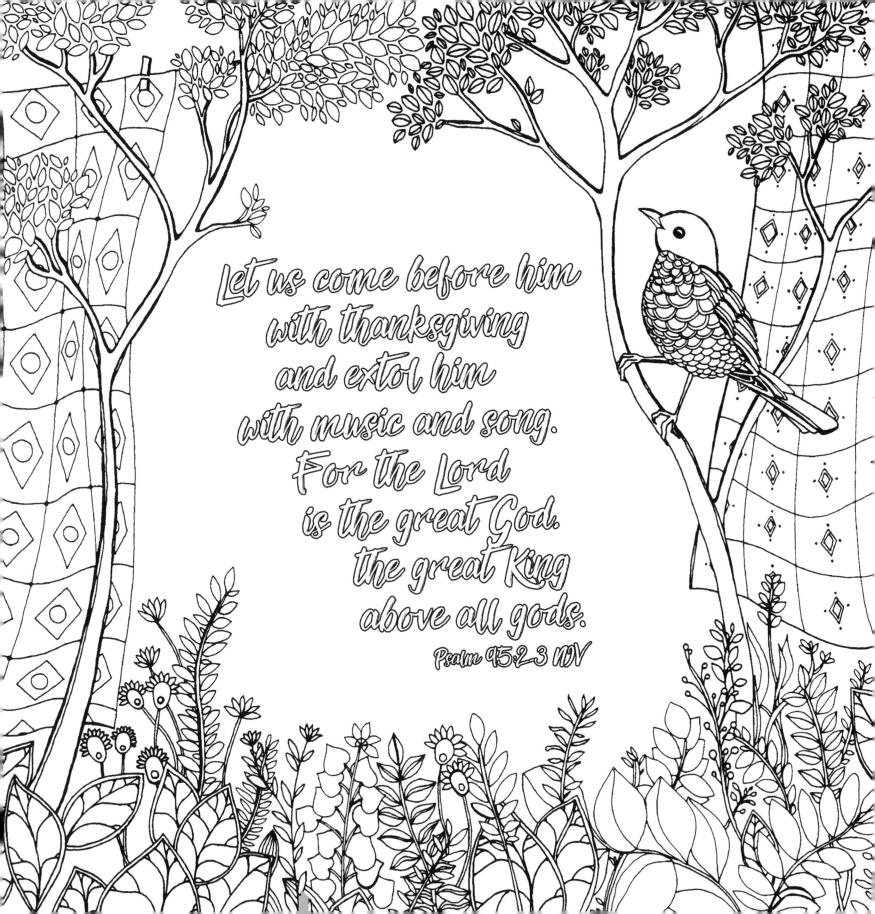

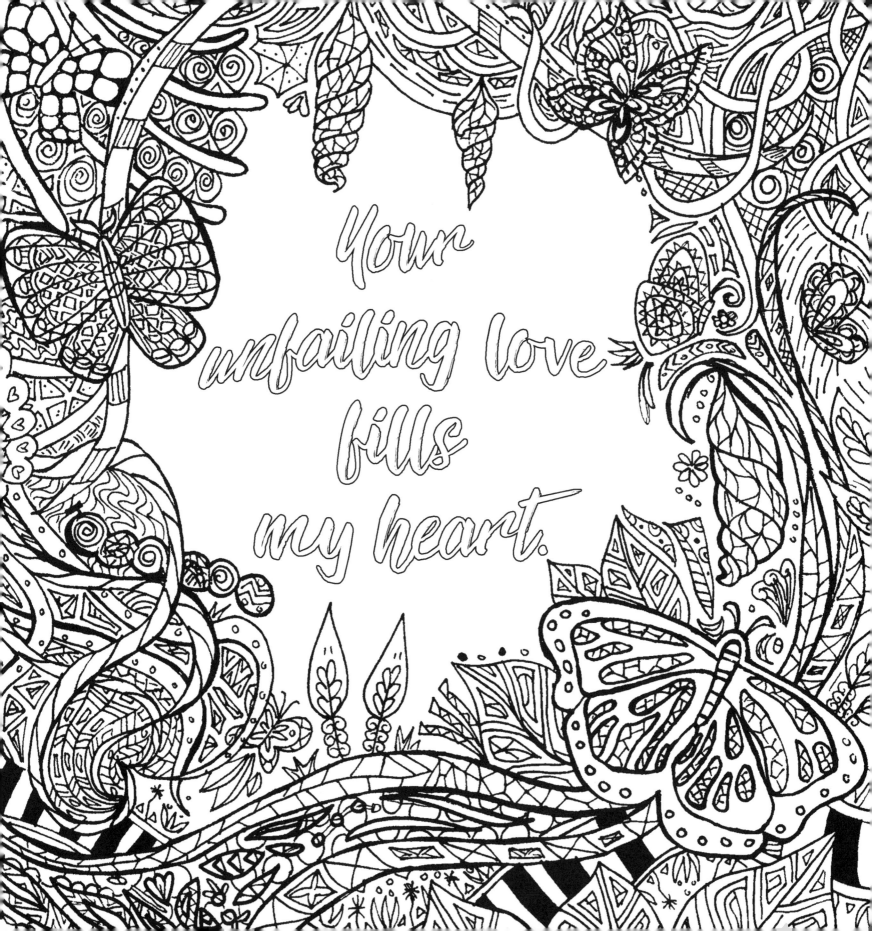